D0902730

IMAGES
of America

SPRINGFIELD, OHIO
REVISITED

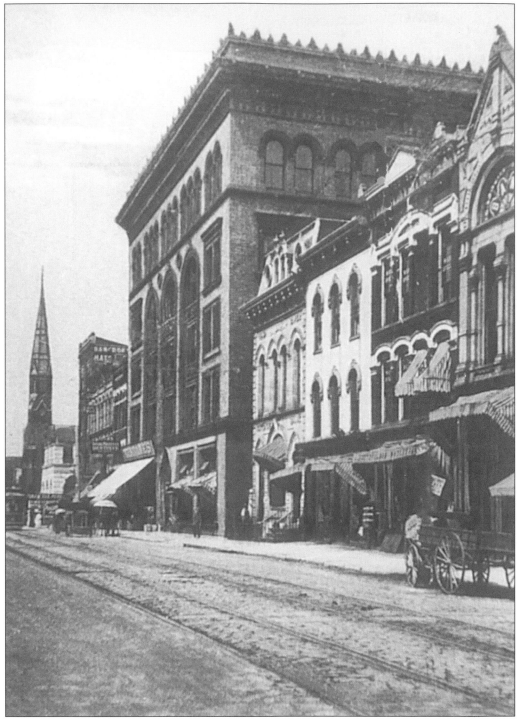

A glance down Main Street in 1909 reveals the famous Bushnell Building, First Presbyterian Church, and Mad River Bank. Trolley cars delivered residents to this center of Springfield's commerce and community.

IMAGES
of America

SPRINGFIELD, OHIO
REVISITED

Harry C. Laybourne

ARCADIA

Published by Arcadia Publishing,
an imprint of Tempus Publishing, Inc.
2 Cumberland Street
Charleston, SC 29401

Printed in Great Britain.

Library of Congress Catalog Card Number: 99-069409

For all general information contact Arcadia Publishing at:
Telephone 843-853-2070
Fax 843-853-0044
E-Mail sales@arcadiapublishing.com

For customer service and orders:
Toll-Free 1-888-313-2665

Visit us on the internet at http://www.arcadiaimages.com

This is a layout of Springfield, so named in 1801, as founder James Demint would have
wanted it.

CONTENTS

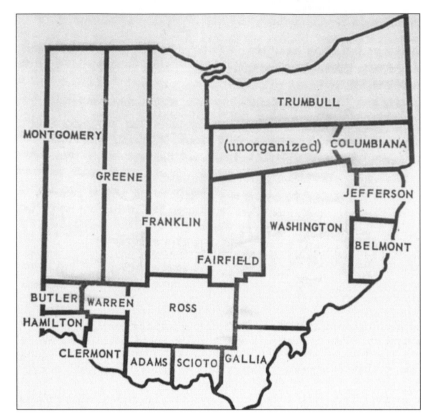

An Ohio map from 1803, the year the state was admitted to the Union, situates Springfield in Greene County. Later, the city would be part of Champaign County, until its final assignment in 1818 to Clark County.

Acknowledgments

The author wishes to thank the following individuals and organizations for their assistance: Ed Baird, Fern Bauer, Mr. and Mrs. Richard Brown, Mr. and Mrs. John Bryan, Mr. and Mrs. Roger Devers, Don Flowers, Mr. and Mrs. William Klenke, Frank Ryan, Mr. and Mrs. Gene Shay, Vern Theopolis, Mr. and Mrs. Harry Van Pelt, the Clark County Library, and Virginia Weygandt of the Clark County Historical Society.

INTRODUCTION

My name is Harry Laybourne, born November 29, 1921, in Springfield, Ohio. Springfield has been my home most of my life. My main purpose in writing this second volume is to expand the view of this compelling city through additional photographs and detail. It is interesting to note that Springfield became a village on March 17, 1801, a town on January 23, 1827, and a city on March 21, 1850.

Also known as Champion City, Rose City, and Home City, Springfield was a vibrant industrial area in the early 20th century. The East Street Works, for example, was second in size worldwide to the Krupps Works, located in Germany. This is just one example of the many industries emphasized in this book, which also examines housing, schools, people, and a thriving downtown community that has seen many changes over the years.

Springfield Census Figures:

1820	610
1900	38,253
1970	81,941
1990	70,987

* * *

Prior to the start of the 19th century, the area that came to be called Clark County was a thriving Shawnee Indian settlement. Despite Tecumseh's efforts to fight colonization and preserve indigenous people's claims to the land, the 1780 Battle of Piqua ushered in a period of settlement that would initiate Springfield's development as a city.

One of Clark County's earliest settlers, James Demint, built a cabin on what was then Buck Creek in 1799, laying the groundwork for what came to be considered one of Ohio's premier small cities. It was the ability to adapt to industrialism, however, that put the city of Springfield on the map.

The earliest hints of such adaptability can be traced back to Springfield's origins in 1801, when Griffith Foos's tavern doubled as a famous stagecoach stop. Three short years later, Springfield's first post office was inaugurated, connecting the city even more fully to the expanding American landscape.

The first half of the 19th century would bring both the Old National Road and a comprehensive railroad system to Springfield, insuring that goods and services found their way

to area residents, and that Springfield's own manufacturing discovered a national market. International Harvester Company, for example, became a leading supplier of farm equipment after Springfield native William Whitely invented the combined self-raking reaper and mower in 1856. Another Springfield resident, Wilbur Gunn, would design England's luxury sports-car, the Lagonda, shortly after the turn of the 20th century.

It is not only industry, however, that makes the city notable. Wittenberg University, one of the state's fine liberal arts institutions, has made its home in Springfield since Ezra Keller founded the school (then Wittenberg College) in 1845. Moreover, architecture buffs have long admired the Burton J. Westcott home, designed in 1905 by Frank Lloyd Wright.

This book is an attempt to document the changing landscape of Springfield, recognizing the additions that have enhanced the city, and the erasures that have placed parking lots and garages where churches, hotels, theaters, and downtown shops once stood.

One
DOWNTOWN

Shown here is the old Cappel's Building (now the Tapestry & Tales Restaurant and Gift Store) c. 1925, purchased at the same time as the old Chamber of Commerce Building by Mr. and Mrs. Art Wilson.

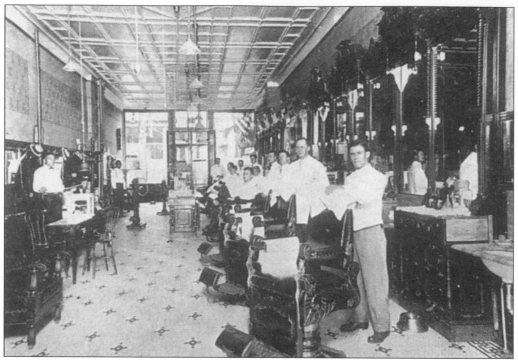

Once, when asked the location of this barbershop in the Arcade, *c.* 1920, the woman who owned the Peanut Store replied, "Right here," then pointed to holes in the floor to prove her point. The barbers, after all, swept cut hairs into the crawl space.

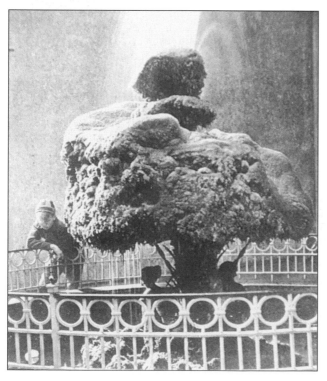

Many people remember feeding the fish in this fountain in the old Arcade Concourse, *c.* 1930.

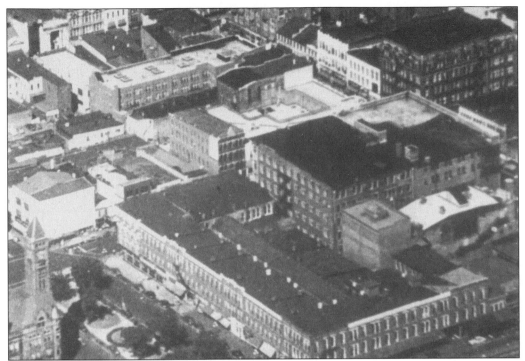

A late 1920s aerial view reveals the Arcade and old City Hall Marketplace, scheduled to open as the Heritage Center in the fall of the year 2000.

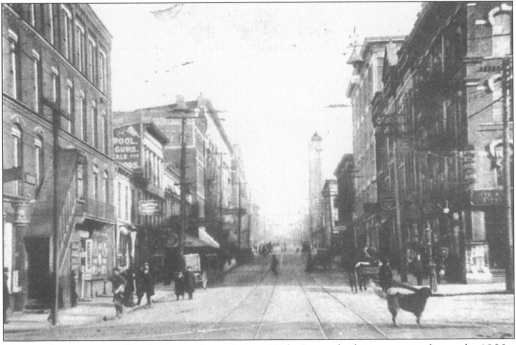

This is the corner of South Fountain and East High Street looking east in the early 1900s. Notice St. Raphael's Church toward the center of the photograph and The When, a men's clothing store, to the right.

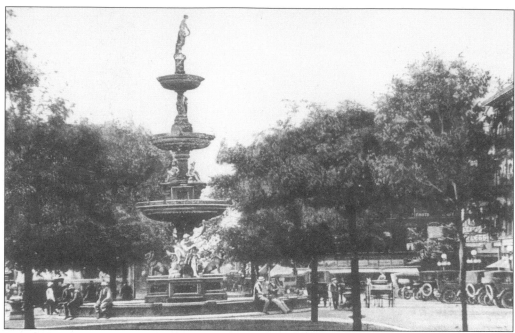

Pictured here c. 1915 is a fountain, rich with animal details, donated to the city of Springfield by Mr. O.S. Kelly. The initial cost to Mr. Kelly was approximately $8,500.

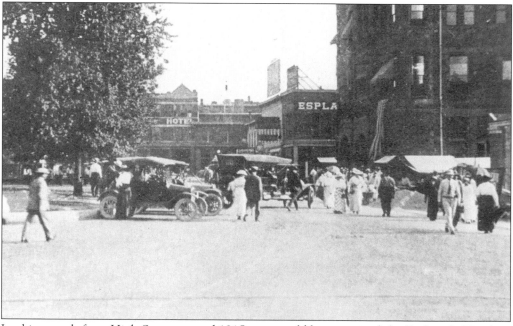

Looking south from High Street around 1915, you would have noticed the Esplanade Hotel on the corner of South Fountain and South Market Streets. Also visible was the Fountain Hotel, which many knew as the Palace Hotel, on the corner of West Washington Street (now the site of the Clark County Library).

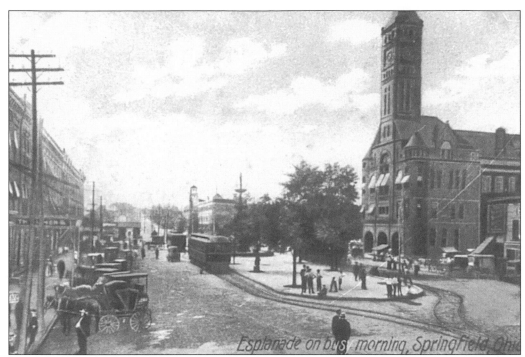

Here is another view of the Esplanade Hotel in the early 1900s, adjacent to a second hotel in the location where Elderly United stands today. To the left you will see the clothing store, The When, as well as traction cars moving down the center of the street.

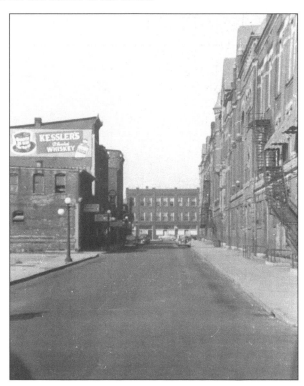

Known anecdotally as the site of the author's first beer, Singer's Bar was probably housed in the South Market Street building that advertised Kessler's Whiskey, pictured here in the late 1940s. This block is now a parking lot.

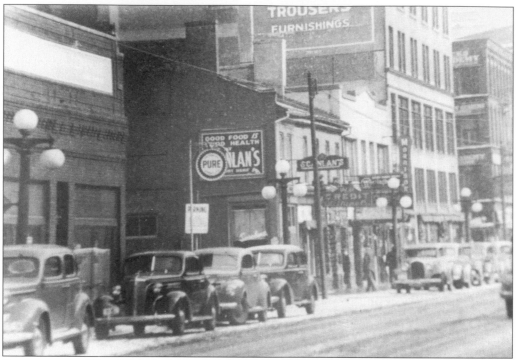

Downtown on West High Street in the 1930s was Scanlan's Restaurant, a place with hearty food also known as Sheridan Restaurant, and later, Sunbeam Restaurant.

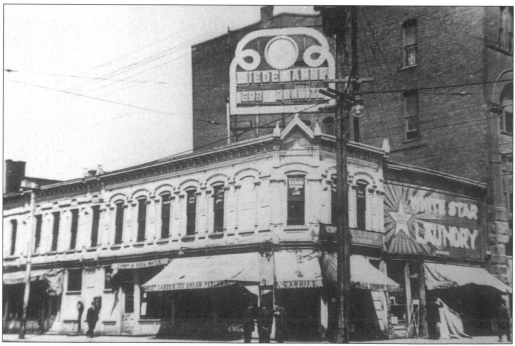

At the northwest corner of Fountain Avenue and West High Street in the early 1900s stood Lagos Ice Cream and Candies alongside North Star Laundry, later replaced by the Arcue Building.

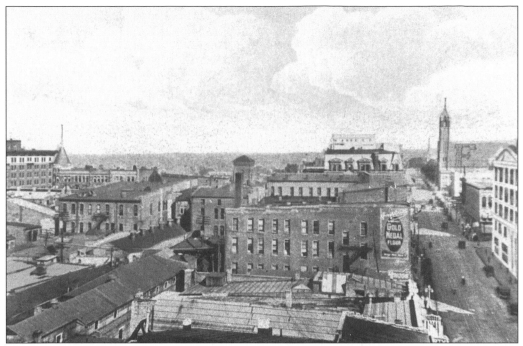

This photograph was taken from the Arcue Building in the 1920s. A discerning eye picks up St. Raphael's Church on the right and the M & M Building, first known as the Gotwald Building (which housed the Springfield National Bank), on the left.

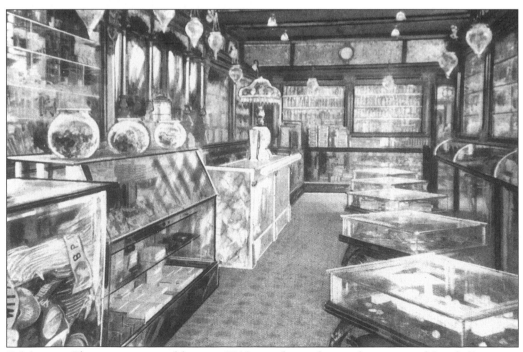

Folchemers Pharmacy, pictured here *c.* 1910, was located near the corner of South Fountain Avenue and East High Street, probably where Oracle's Vision is today.

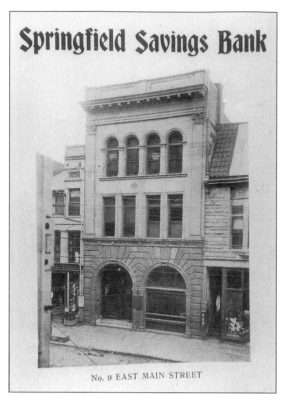

Springfield Savings Bank

No. 9 EAST MAIN STREET

Springfield Savings Bank was located at 9 East Main Street, across the street from Lagonda National Bank, at the turn of the century. It can now be found on the southwest corner of Main Street and Fountain Avenue, where the M.D. Levy men's store was located.

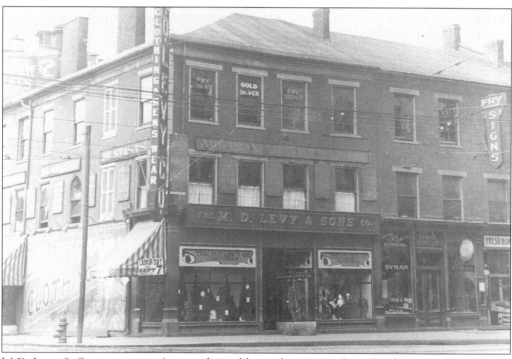

M.D. Levy & Sons was a men's store that sold just about everything for the modern gentleman of the 1910s.

Featured here is the Lagonda National Bank, *c.* 1920, at the northeast corner of Main Street and Fountain Avenue. Notice the meeting of the old and the new, with a horse drawn carriage parked beside a conspicuous sign of technology.

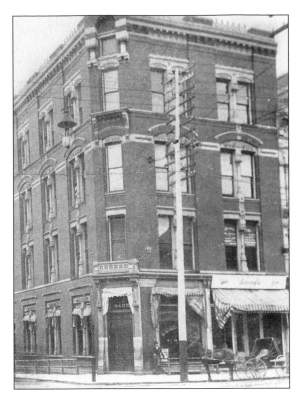

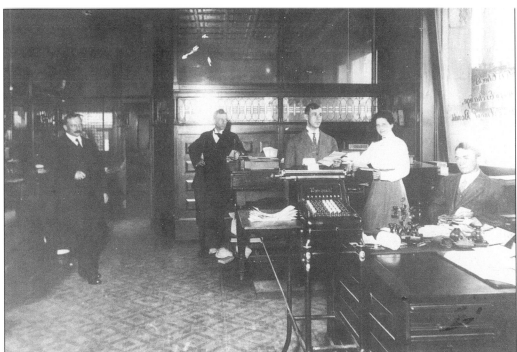

This photograph shows the personnel and interior of the old M & M Savings & Loan Association in 1910.

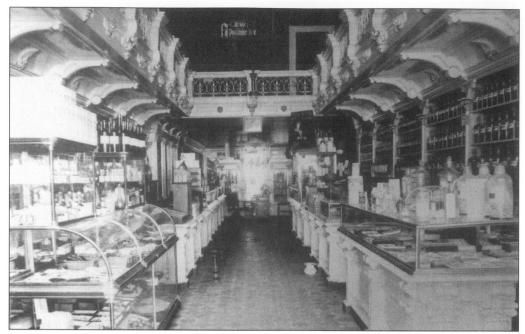

Customers were waited on along the upper railings of the Ludlow Drug Store, shown here *c.* 1910. Presumably, this nearly made theatre of the pharmacists' work, offering the public a bird's eye view.

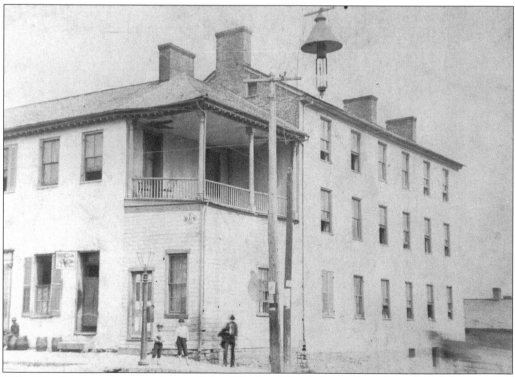

Billy Werden was the proprietor of the Werden Hotel, located at the northwest corner of Spring Street and East Main Street.

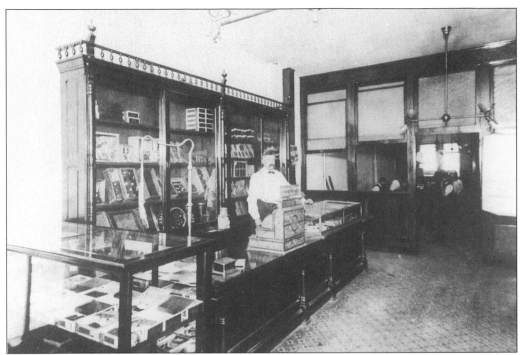

Pictured here is one of the many cigar manufacturers in the city of Springfield, *c.* 1910.

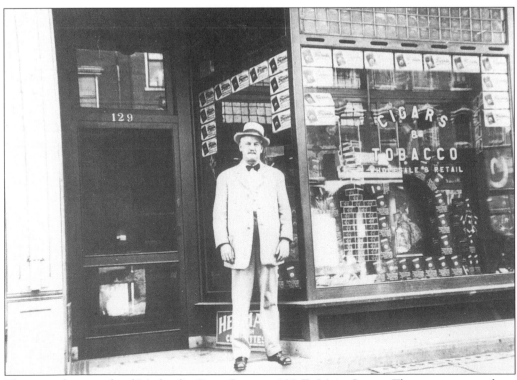

This is a photograph of Michael's Cigar Store at 129 E. Main Street. The owner poses for a picture in front of this location, where he probably also made the cigars.

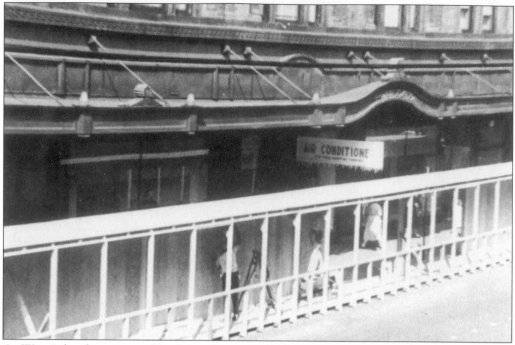

At Wren's last location on East Main Street in the late 1930s or early 1940s, air conditioning was featured as a sales incentive.

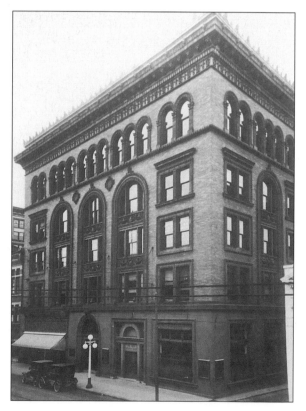

According to the author's understanding, the Bushnell Building, pictured here in the early 1910s, was originally constructed as an office building with ninety individual spaces.

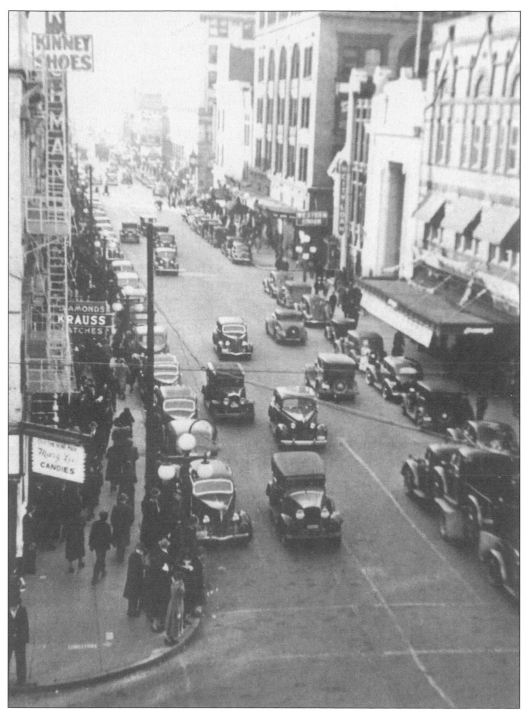

Cars and pedestrians line the busy downtown area of the late 1930s, demonstrating the vitality of the Springfield Savings & Loan, and success of retail stores like Penney's, Mary Lee's Candies, Krauss Jewelers, Kinney Shoes, and Richman Brothers.

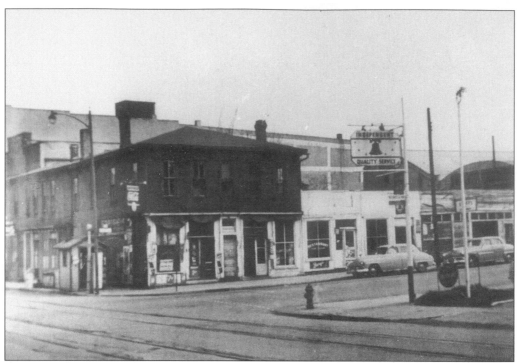

Known now as the Clark County Library, this is the southeast corner of Center Street and West Washington Street in the late 1940s. Notice the sign for "Independent Quality Service" that foreshadows one of the great contemporary debates surrounding downtown development.

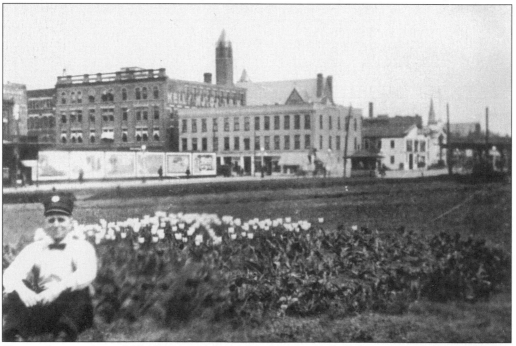

Here, a fireman from old firehouse #1 takes a break against a backdrop of St. Raphael's Church and the downtown "skyline" of the 1910s.

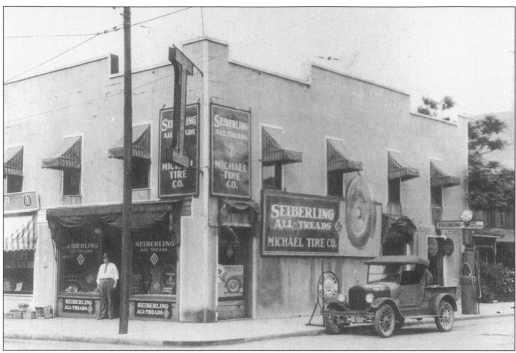

A sign of the times *c.* 1910 is Seiberling All-Treads, a tire company on the northeast corner of North Street and Fountain Avenue, now the location of a law building.

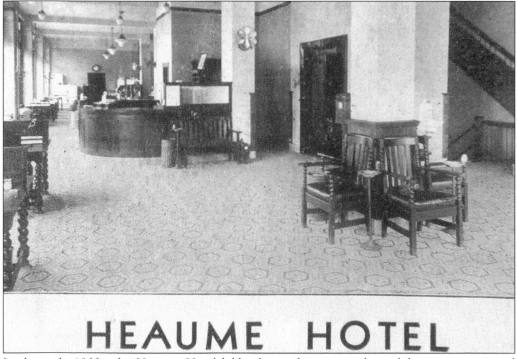

HEAUME HOTEL

In the early 1900s, the Heaume Hotel lobby featured ornamental wood furniture, patterned flooring, and a centralized desk where guests checked in.

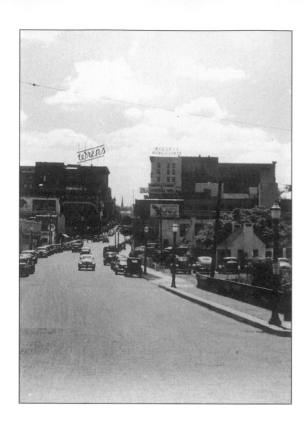

Modern advertising hovers above North Fountain Avenue at the bridge in the 1930s.

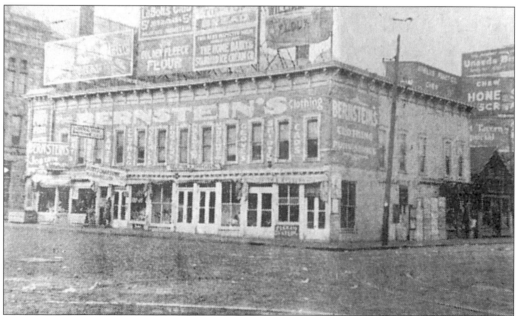

Many will remember the sign-bedecked structure on South Fountain Avenue at the southwest corner of High Street, which was replaced in 1917 by Myers Market. This photograph from the 1900s features Bernstein's Department Store in the center as well as a detail of City Hall, upper left.

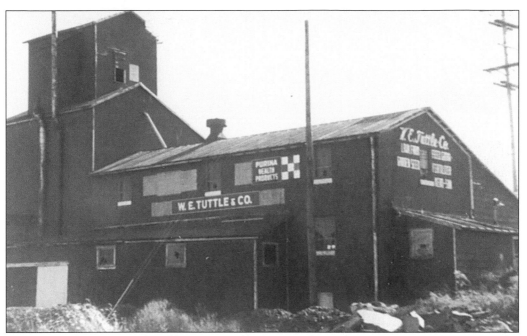

Many should recognize the old W.E. Tuttle Company, *c.* 1920, on Monroe Street near the present Kuss Center.

The structure next to the County Building is the K.R.O. Building, so named for a business known as "Kills Rats Only," *c.* 1910. After World War II, the building would become a dealership for Kaiser automobiles, while today it serves as a parking garage.

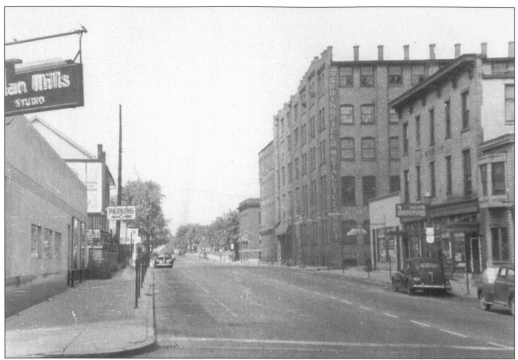

Take a glance at this 1930s view of West Columbia at North Fountain Avenue, which reveals the Olan Mills Studio to the left and Springfield Metallic Casket across the street.

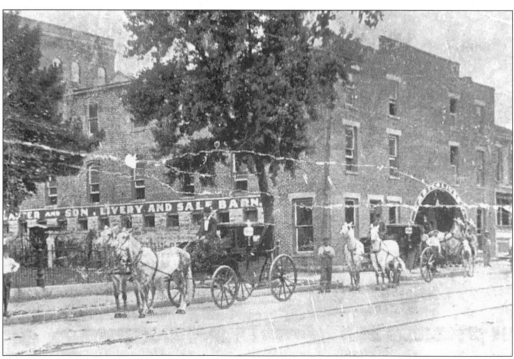

This 1890 photograph shows Livery & Sales Barn on East Columbia Street near North Limestone Street, where a parking garage now stands.

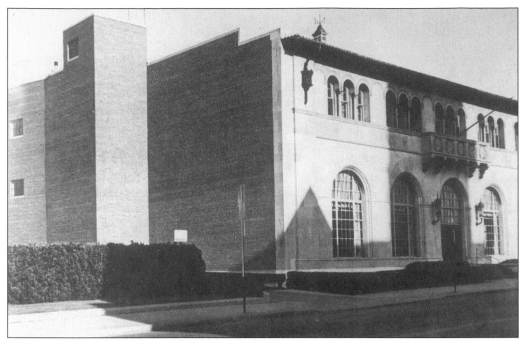

Many Springfield residents will remember this building, home to the *Springfield News-Sun* newspaper owned by Cox News. This site was the former residence of Dr. Richard Rogers, who later built a palatial home in the country now owned by Littleton & Rue Funeral Home.

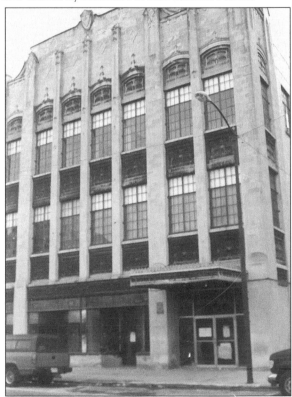

WIZE, a Springfield radio station, was one of the first tenants of the building pictured here, recently demolished to make room for a parking lot. WIZE created a small scandal by broadcasting beer commercials through the sound system of Central United Methodist Church, even on Sundays.

141 South Limestone Street is now occupied by the performing arts group of Clark State.

Pictured here in the 1890s are two employees of Ohio Edison Company, formerly Springfield Light, Heat & Power Company.

Two

RESIDENCES

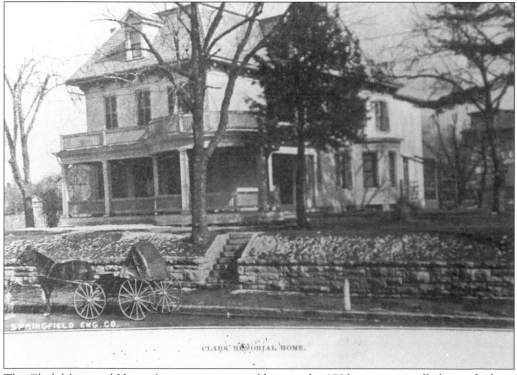

The Clark Memorial Home for women, pictured here in the 1890s, was originally located where the 616 Building now stands. The Home moved to 106 Kewbury, where it continues to operate.

This building, from a 1910s photograph, is located at 504 E. High Street behind LaFemme Beauty Salon. James Demint, founder of Springfield, lived in a house like this copy on College Avenue. A large stone marks the spot where he lived. The Springfield Board of Education now occupies the College Avenue location.

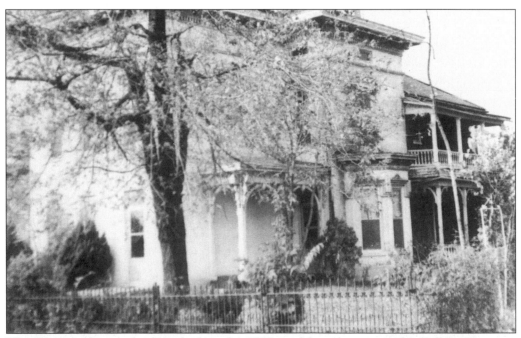

The Weimer House, photographed in the 1920s and later known as the Kalbfus House, is located at 648 East High Street.

Pictured in the 1920s, this home, located at 1002 East High Street and built for Mr. Blee (a beer distributor), is now the Jones-Kenney-Zechman Funeral Home.

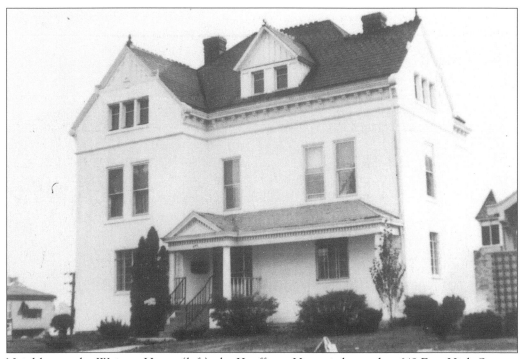

Neighbor to the Weimer House (left), the Kauffman House is located at 649 East High Street.

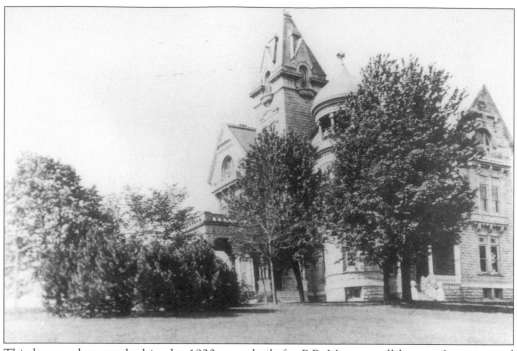

This home, photographed in the 1920s, was built for P.P. Mast, a well-known figure around Springfield. The house was sold to the Knights of Pythias in 1914 for $15,000.

Originally built for Mr. Charles Clark, the Woman's Town Club occupies this building at 805 East High Street, pictured here in the 1920s.

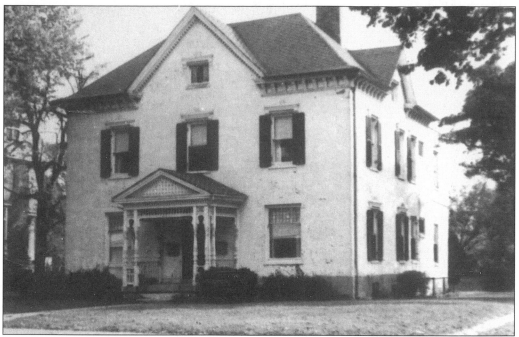

A photograph from the 1920s features the Yeazell House, located at 905 East High Street.

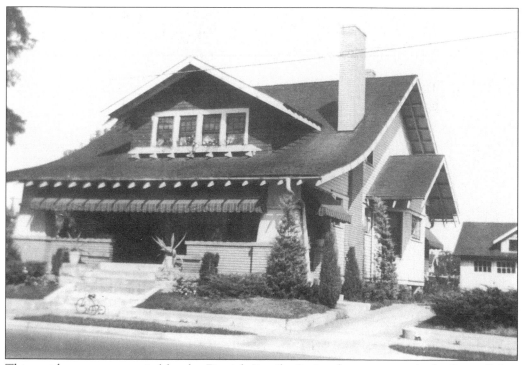

This residence was occupied by the Detrick Family. In its place now stands the Larry Baker Insurance Agency, originally constructed by Mr. Hoppes as the Prudential Building.

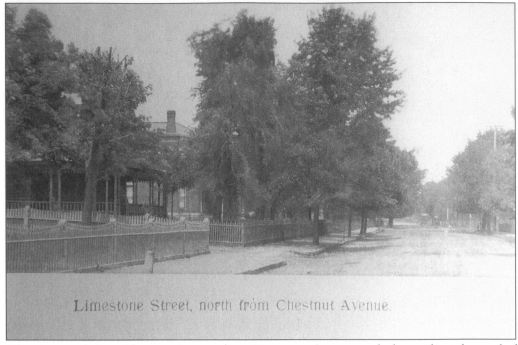

Limestone Street, north from Chestnut Avenue.

Glancing north from Chestnut Avenue down Limestone Street reveals the residential appeal of wooded lots and picket fences in the early 1900s.

The site of the Rodgers Home has seen many transformations since the early 1900s, when this photograph was taken. Dr. Rodgers originally purchased the lot, where the Springfield Newspaper Company stands today, for the purpose of building his mansion. The building was bought by Mr. Herbert Littleton in 1938 and converted to a funeral home.

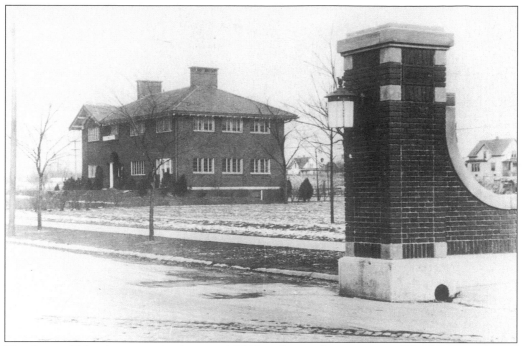

The famous Eakin home was built around 1915 at the northeast corner of North Fountain and West McCreight Avenue. Miss Betty Eakin married Dr. Ryan (now deceased), and currently lives in Columbus, Ohio.

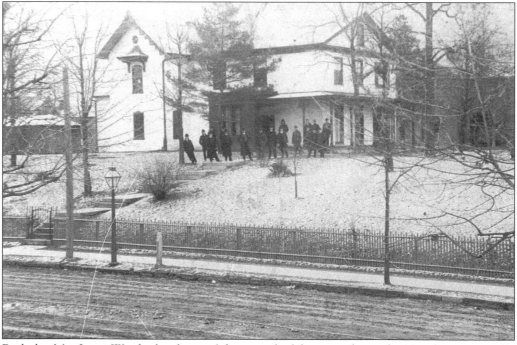

Built by Mr. Isaac Ward, this home (photographed here in the early 1900s) was initially purchased by Chilton Gano, and later by Mr. Ron Duncan of American Express. The building remains standing today.

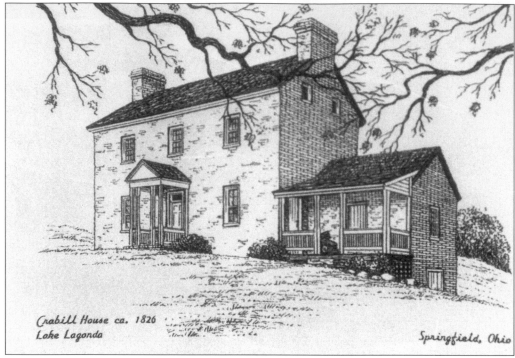

Crabill House ca. 1826
Lake Lagonda

Springfield, Ohio

Originally built and owned by David Crabill, The Crabill Home is now owned by the Clark County Historical Society and maintained by the Crabill heirs. The building has remained in the family since its construction in the early 19th century.

A sorority from Wittenberg University now occupies this home, pictured in the 1920s and originally owned by Gus Sun, at 840 North Fountain Avenue.

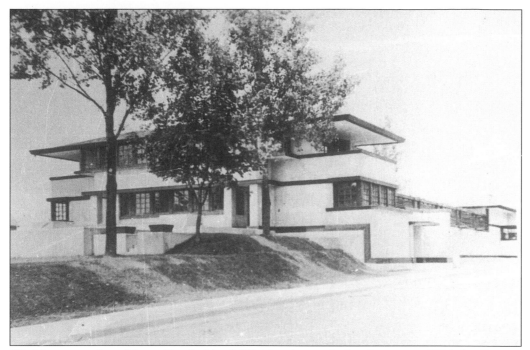

World-renowned architect Frank Lloyd Wright designed this home in 1904 for Burton Westcott, an automobile-manufacturer of Springfield. The building still stands at its 1340 East High Street address, but is in great need of repair.

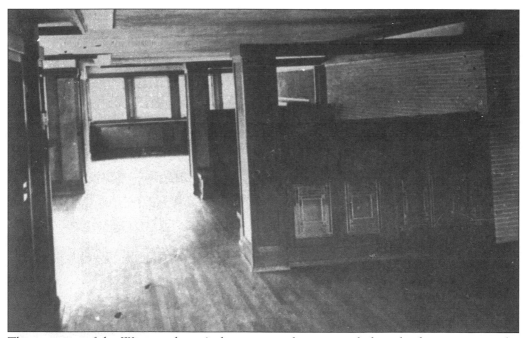

This is a view of the Westcott home's three principal rooms, including the dining room at the far end, c. 1908. Notable are Wright's standard design principles, from expansive spaces to ornamental windows to natural building materials.

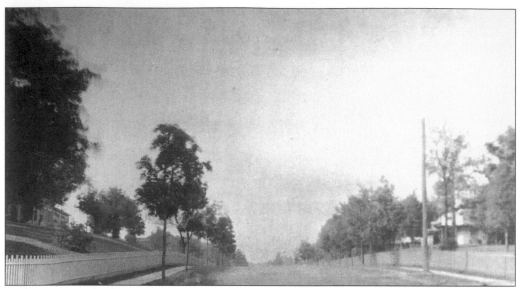

This is an 1890s view of Market Street, looking from the North Fountain Avenue Bridge. Visible on the right is likely the Ward Home.

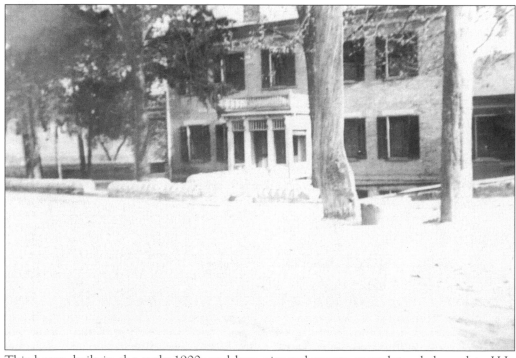

This home, built in the early 1900s and here pictured twenty years later, belonged to H.L. Heistand, a medical doctor.

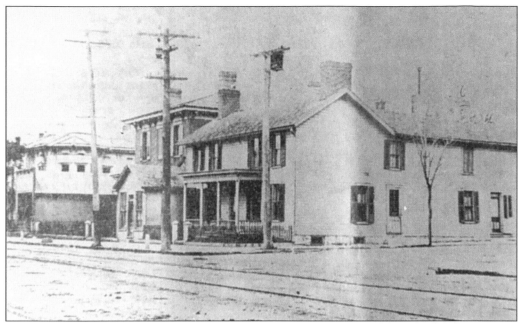

Shown here in the late 1870s, this residence at the corner of West High Street and South Wittenberg Avenue was later the site of a factory built by the Crowell-Collier company.

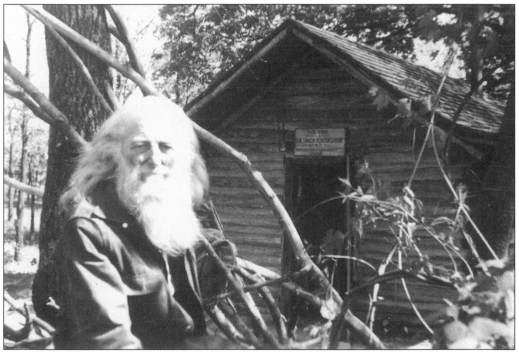

This photograph from the 1930s demonstrates the effect of illness on one's concept of home. David O. Steinberger, a retired Wittenberg College professor suffering from tuberculosis, sought the curative power of outdoor air by living among it. It is unclear from this photo whether Professor Steinberger actively selected the woods as his home, or was strongly encouraged to do so.

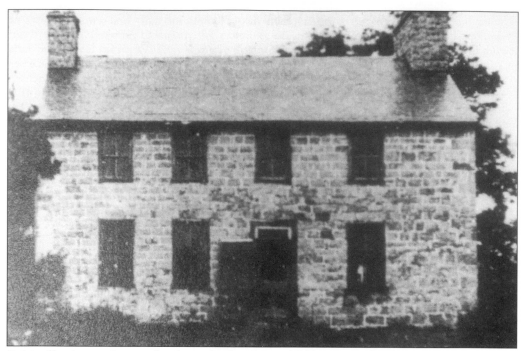

Originally the residence of military leader General Whiteman, this home, c. 1890, is now owned by Mr. Brown of the Drug Castle chain. It is also believed to have been a stop on the Underground Railroad during the Civil War.

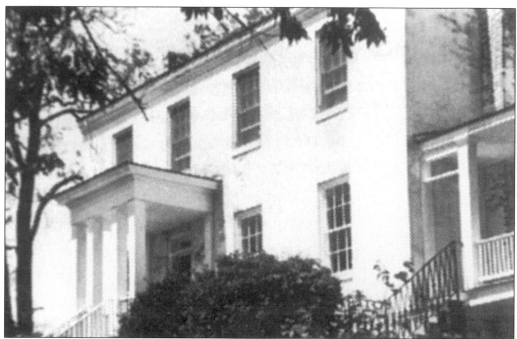

This building, the famous Hertzler Home c. 1890, is notorious for two reasons: the eight porches—one constructed for each of Daniel Hertzler's children—and the tragic, financially-motivated murder of Daniel in 1867.

Three

SCHOOLS

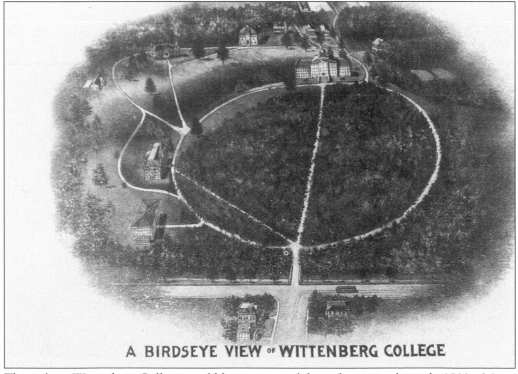

A BIRDSEYE VIEW OF WITTENBERG COLLEGE

This is how Wittenberg College would have appeared from the air in the early 1900s. Myers Hall is visible at the top of the photograph.

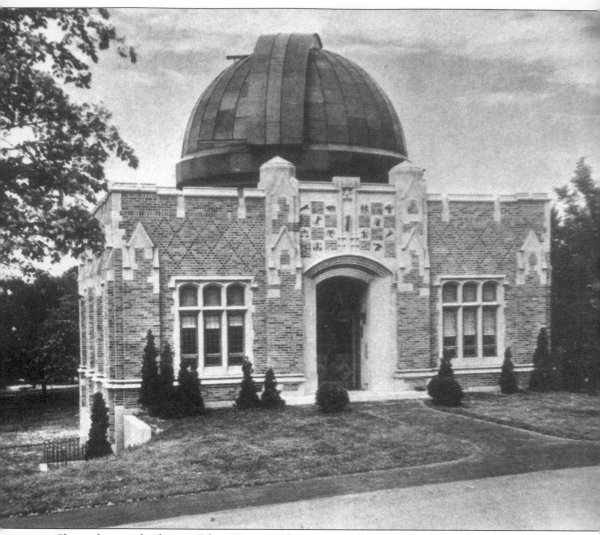

Shown here is the famous Edgar Weaver Observatory at Wittenberg College, *c.* 1920.

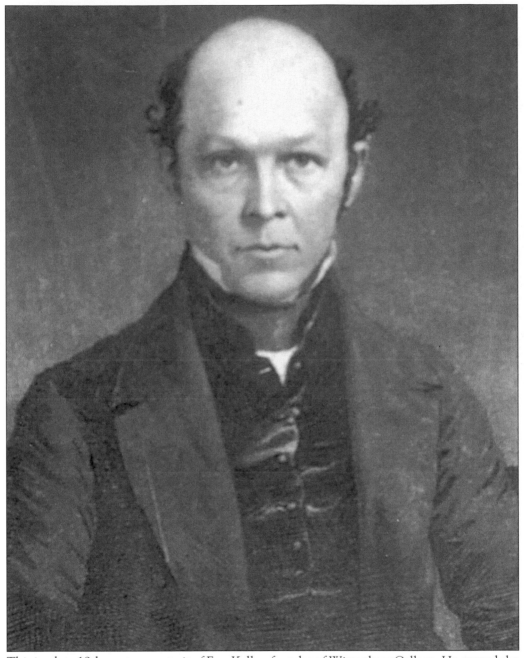

This is a late 19th century portrait of Ezra Keller, founder of Wittenberg College. He started the institution out of the basement of the First Lutheran Church at an annual salary of $450.

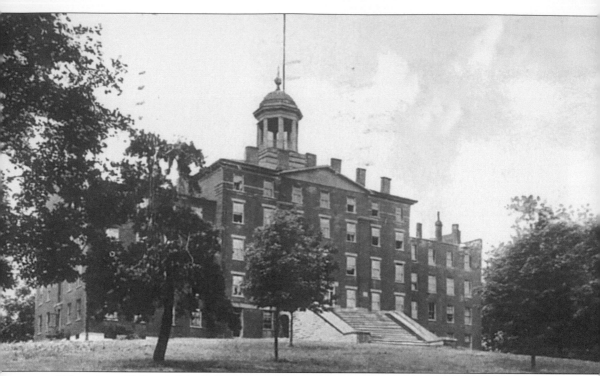

Wittenberg College's Men's Dormitory, shown here in the 1860s, would later be adapted for instructional purposes and renamed Myers Hall.

The Snowhill School was erected in 1890 and photographed here shortly thereafter. The building is now occupied by a professional person.

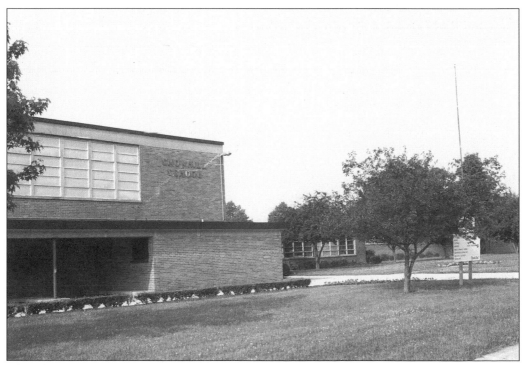

This photograph from 1953 or 1954 features the new Snow Hill School in its infancy. The school, located at 531 West Harding Road, was constructed in 1951, and refurbished with additions two short years later.

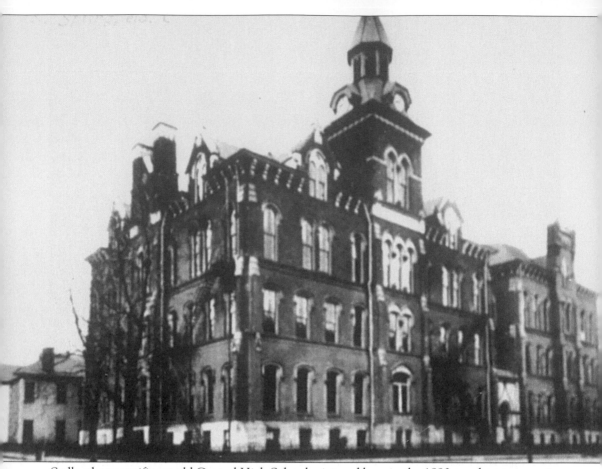

Sadly, the magnificent old Central High School, pictured here in the 1890s, no longer occupies the corner of South Wittenberg Avenue and West High Street. The site would later become the Crowell Collier parking lot.

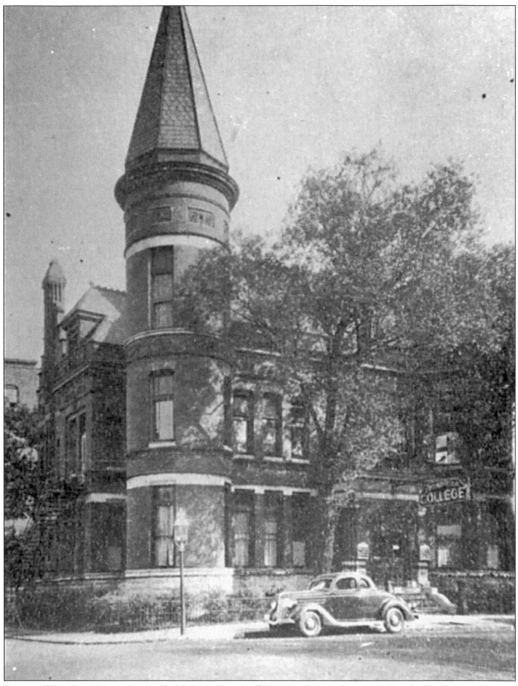

Pictured in the 1930s, Springfield Business College was located at 350 South Limestone Street in a lovely Victorian building.

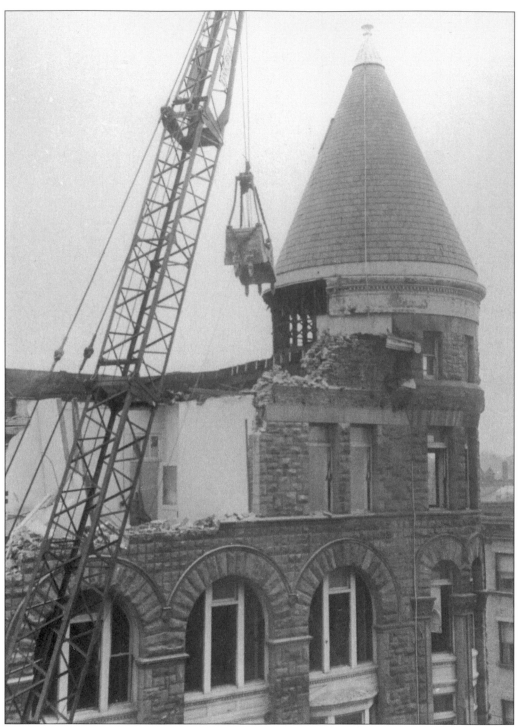

This may be one of the last surviving photographs of the St. Raphael's Church elementary school, originally the old US Post Office at the northeast corner of East High and South Spring Street. The building is shown here in the 1960s under demolition for use as a parking lot by the Parish.

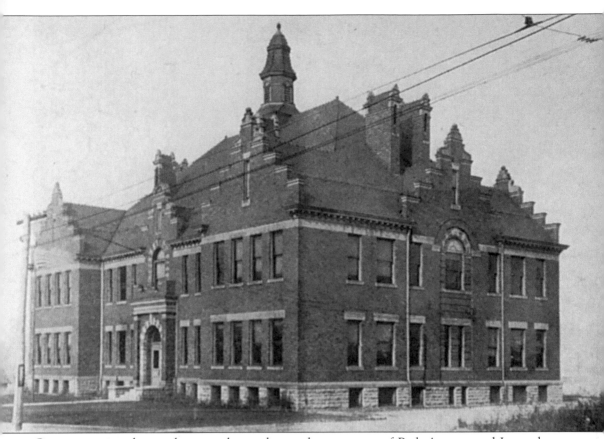

Once occupying the nearly empty lot at the northwest corner of Park Avenue and Lagonda Avenue is Washington School, shown here in the early 1900s. Only a school warehouse remains on the site.

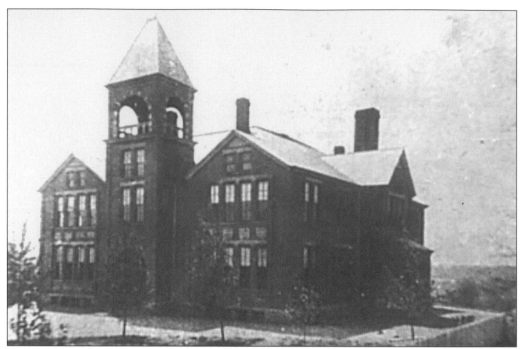

This is an 1890s photograph of Gray School, forerunner of the Grayhill School, where the Pepsi Plant stands today at 233 Dayton Avenue.

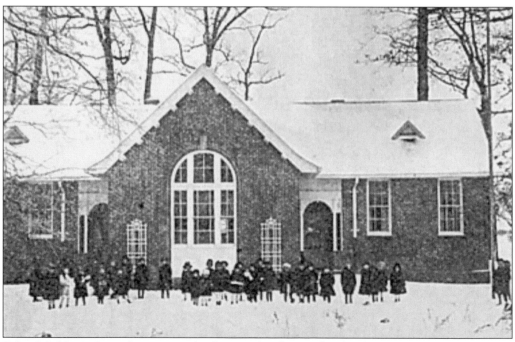

Schoolchildren cheer this wintery landscape of Ridgewood School, located at 25 W. Harding Road, in the 1920s or 1930s. The school eventually moved to another location off St. Paris Pike, and a doctor's office now occupies the original building.

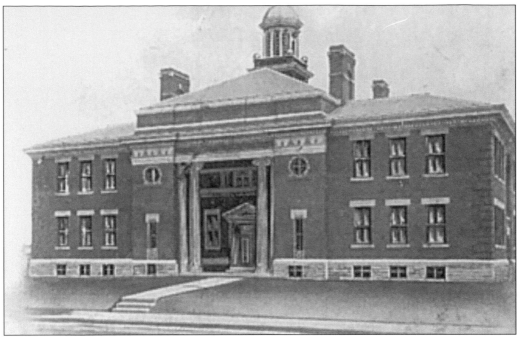

Now set aside for students with severe disabilities, the Elmwood School (*c.* 1910) was originally constructed in 1903. The 1950s brought needed additions to the building at 280 South Clairmont Avenue.

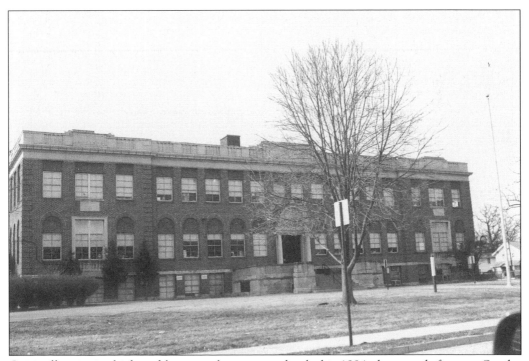

Originally a junior high and later an elementary school, this 1994 photograph features Snyder Park School.

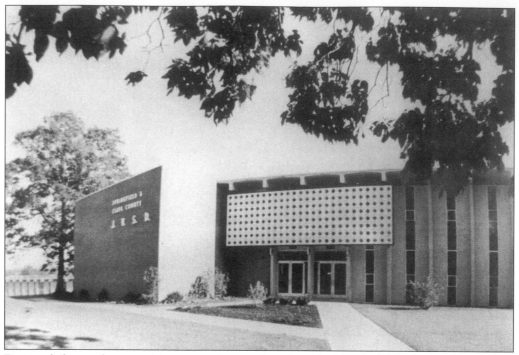

Designed for students aspiring to professional trades, the Springfield-Clark County Joint Vocational School, pictured here in the 1960s, is located at 1901 Selma Road.

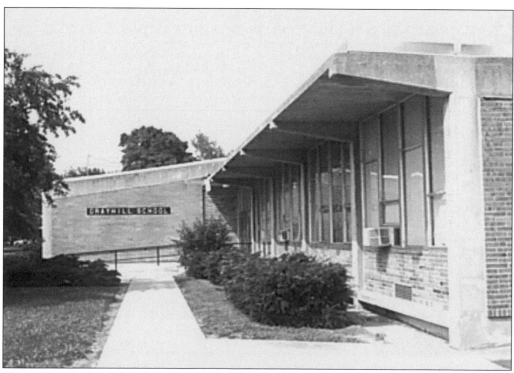

Shown here is Grayhill School at 251 Montgomery Avenue in 1994.

Four

PEOPLE

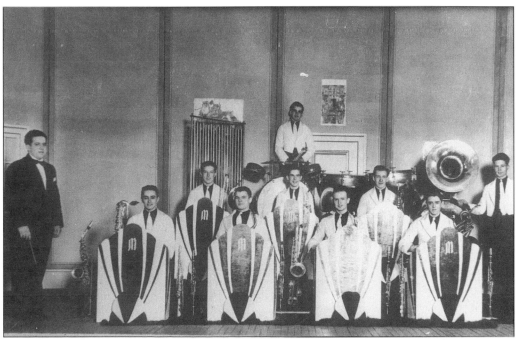

Curly Martin's Orchestra was a featured performer around Springfield. Their music would certainly be popular today with the resurgence of styles like big band and swing.

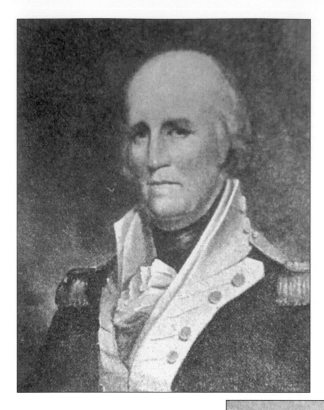

This portrait from the 1790s provides an image of General George Rogers Clark, after whom Clark County was named.

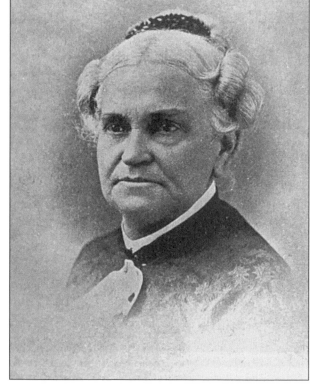

Taken in the 1890s, this is a portrait of Mother Stewart, who worked along with Frances Willard for the Women's Christian Temperance Union. Ms. Stewart was not alive to see the ratification of the eighteenth amendment (which instituted Prohibition) on January 16, 1920.

Pictured here in the 1890s is one of Springfield's great leaders, Oliver S. Kelly, who started the famous Arcade and built the first fountain in the Esplanade, which he donated to the city.

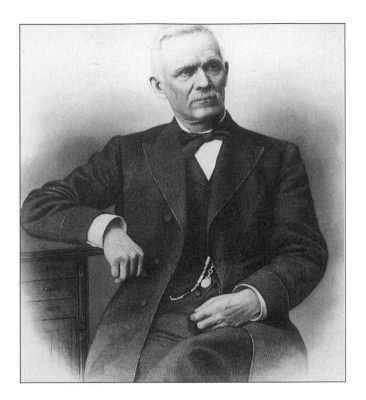

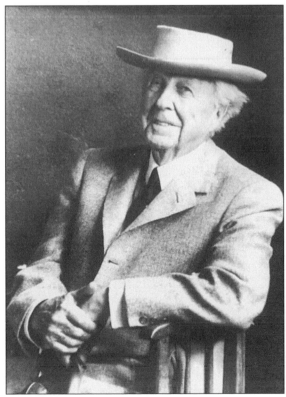

Though not a native son of Springfield, Frank Lloyd Wright influenced its landscape by designing and building the Burton Westcott house at 1340 East High Street. This is a portrait of the architect in the 1920s, approximately two decades following the completion of the Westcott home.

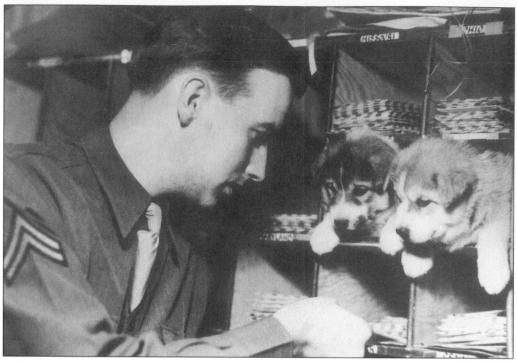

While on duty in Alaska in 1944, the author of this book sorts mail before the watchful eyes of two puppies.

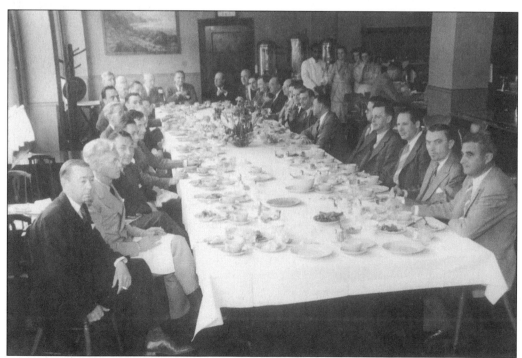

Businessmen gathered weekly to eat at the Heaume Hotel, shown here in 1937, where the waitresses knew them by name.

The Hippodrome Theatre at 57 West Main Street was a mainstay of Springfield's theatre business in the 1920s. When people facetiously mentioned the free shoeshine you could receive there, they were referring to the rats known to run across patrons' shoes.

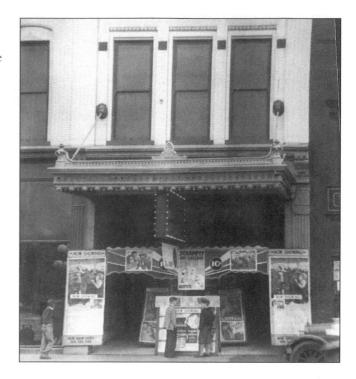

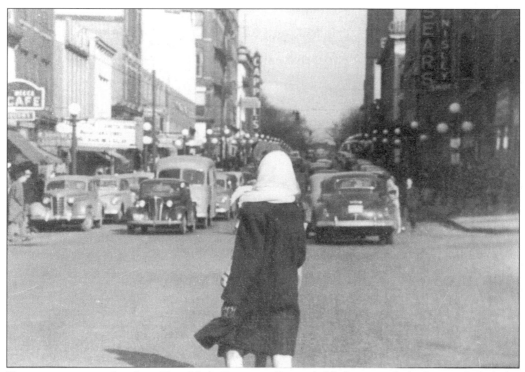

Two women cross bustling East High Street, a Springfield shopping hub that included the Liberty Theatre, Mecca Café, and Sears.

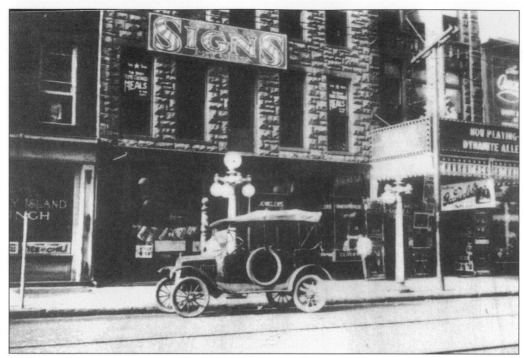

Visible on the right of this photograph from the 1920s is the Princess Theatre, located across the street from the First National Bank building, and the first theatre owned by the Chakeres family.

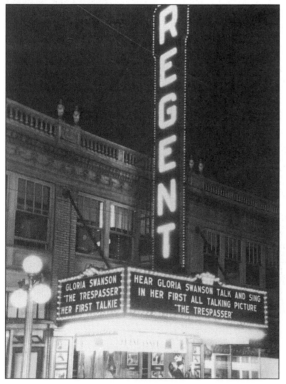

The Regent Theatre was a popular attraction for Springfield residents. Here, the marquee advertises Gloria Swanson's first role in a "talkie," the 1930s film, *The Trespasser*.

Five

BUSINESS

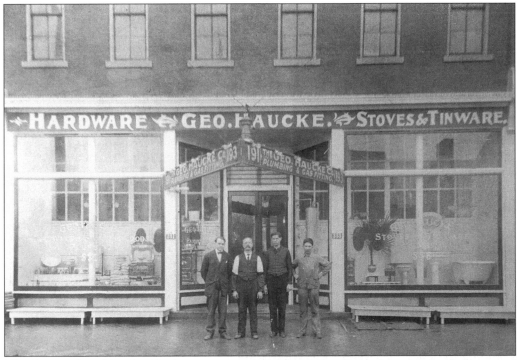

The famous Geo. Haucke Hardware store at 331 West Main Street has withstood the test of time since this 1920s photograph was taken. Unlike many of its contemporaries, the store continues to do a thriving business at its original location, and has certainly expanded its early emphasis on "stoves & tinware." Here, owners demonstrate the pride that carried them through so many decades of success.

DEPRESSION ERA SHOPPING LIST
1932–1934

Automobiles:
(NEW)
Pontiac coupe $585.00
Chrysler sedan 995.00
Dodge 595.00
Studebaker 840.00
Packard 2150.00
Chevrolet 650.00
 half-ton pick-up

Clothing:
(WOMEN'S)
Mink coat $585.00
Leopard coat 92.00
Cloth coat 6.98
Raincoat 2.69
Wool dress 1.95
Wool suit 3.98
Wool sweater 1.69
Leather shoes 1.79
Reptile shoes 6.00
(MEN'S)
Overcoat $11.00
Trousers 2.00
Shirt 47¢
Pullover sweater 1.95
Silk necktie 55¢
Tuxedo 25.00
Stetson hat 5.00
Shoes 3.85

Household Items:
Double-bed sheets 67¢
Bath towel 24¢
Wool blanket 1.00
Linen tablecloth 1.00
Wool rug (9 X 12) 5.85
Electric iron 2.00
Coffee percolator 1.39
Electric mixer 9.95
Vacuum cleaner 18.75
Washing machine 47.95
Gas stove 23.95
Sewing machine 24.95

Furniture:

Dining room set 46.50
Bedroom set 49.50
Lounge chair 19.95
Bridge table 1.00
Wing chair 39.00
Grand piano 395.00

Real Estate:
Modern house $2800.00
(6 rooms plus
garage, Detroit)
English cottage 4350.00
(8 rooms, 3 baths,
1 ballroom)

Food:
Rib roast, per lb. 22¢
Bacon, per lb. 22¢
Ham, per lb. 31¢
Chicken, per lb. 22¢
Pork chops, per lb. 20¢
Salmon, 16 oz. can 19¢
Milk, per quart 10¢
Butter, per lb. 28¢
Margarine, per lb. 13¢
Eggs, per dozen 29¢
Cheese, per lb. 24¢
Cornflakes 8¢
Loaf of bread 5¢
Coffee, per lb. 26¢
Sugar, per lb. 5¢
Potatoes, per lb. 2¢
Dozen oranges 27¢
Bananas, per lb. 7¢
Onions, per lb. 3¢
Tomatoes, 9¢
 16 oz. can

Miscellaneous:
Dental filling $1.00
Toothpaste 25¢
Cigarettes 15¢
Pipe 83¢
Gallon gasoline 18¢
Kodak Brownie
Camera 2.50

Springfield Water Works operated the standpipe (pictured here in the 1940s), which held a 500,000 gallon reserve. The standpipe was actually built in 1881 with the use of a boat; a man inside the boat riveted the inside, while another riveted the outside. When finished, they threw the boat away. Later, the standpipe's location moved to East Main and Florence Streets.

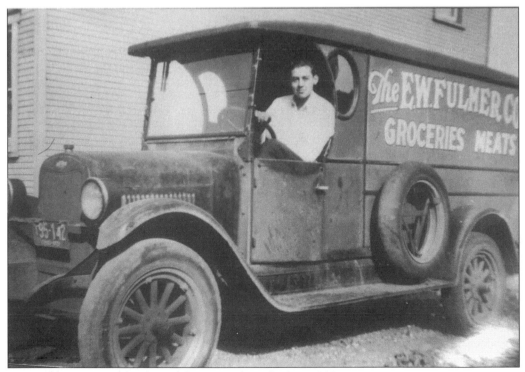

Pictured here is an old Fulmer delivery truck in the late 1920s.

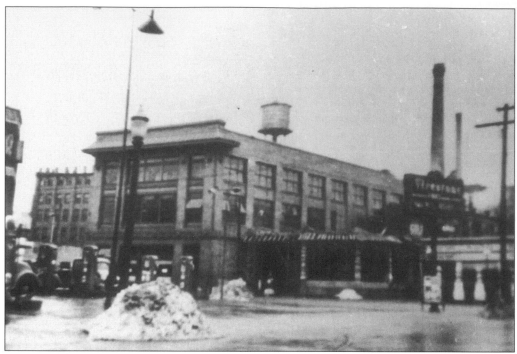

This corner of North Fountain Avenue and North Street has seen many changes since the 1930s. Purity Dairy is now the Huntington Bank building, and the Firestone Store—which sold automobile supplies and gasoline—is now the City/County Safety building.

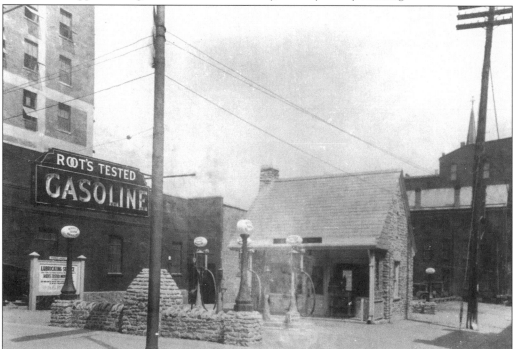

Note the old-fashioned gas pumps at Root's Tested Gasoline c. 1930, a filling station located next to the Tecumseh Building on West High Street.

Known for good donuts, this building remains under the name of Schuler's. The business moved from its original location at 402 East Main Street into the Dawn Donut building in the 1940s. This image from the 1920s predates the relocation.

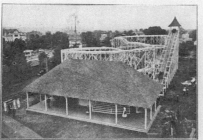

Spring Grove Park
FREE TO THE PEOPLE

SUPPORTING

The Most Beautiful Summer Theatre
IN THE MIDDLE WEST

CAVE OF THE WINDS, SHOOTING GALLERY, HOUSE OF TROUBLE, PHOTOGRAPH GALLERY,
LAUGHING GALLERY, FREE BAND CONCERTO, MERRY-GO-ROUND,
FREE SWINGS, FIGURE EIGHT, DANCING.

FOR
Fascinating
Fun
Have a
Ride
on the
FAMOUS
FIGURE
EIGHT

A
Safe,
Sensational
and
Sure
Cure
for
the
Blues

SPECIAL LOW EXCURSION RATES
FOR
LODGE, CHURCH, SCHOOL AND OTHER PICNICS
Ample Shelter in Case of Rain. Special Attention Shown to Ladies and Children.

Those wishing to secure dates ahead, address

Phone 284 C. F. POWELL, Manager

SEASON OPENS MAY 30th -- DECORATION DAY

An early 1920s advertisement for Spring Grove Park (known as Avalon to most Springfield residents) shows the popular roller coaster.

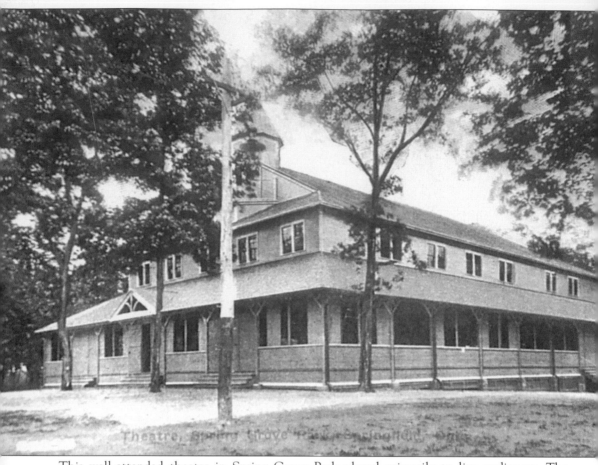

This well-attended theater in Spring Grove Park played primarily to live audiences. The inviting building is shown here in the early 1920s, its heyday of popularity. Some may still remember hearing music or watching a theatrical performance inside.

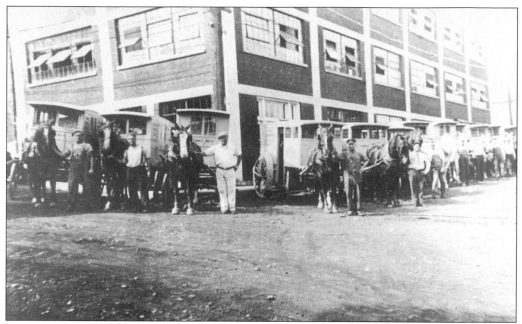

Penn Street Hill, located behind this building on East Main Street, was the infamous scene of a murder of two little girls. The building itself was once a dairy.

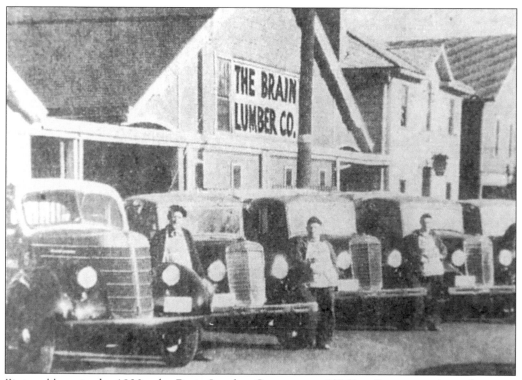

Pictured here in the 1930s, the Brain Lumber Company at 401 East Street remains in business today after over 130 years.

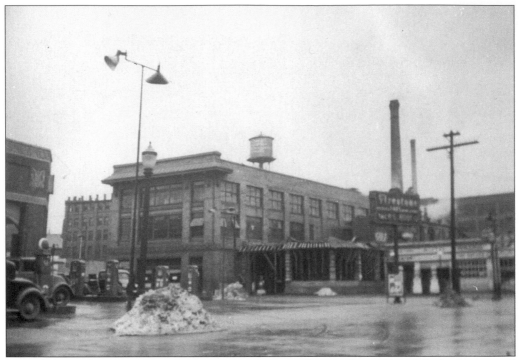

This photograph of the Springfield Purity Dairy was taken in the 1930s. H.G. Root operated the Firestone store, which featured one gasoline filling station directly across the street from another.

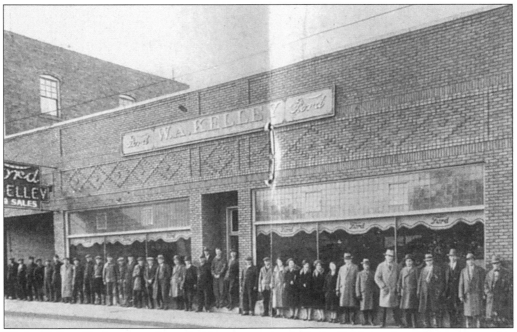

W.A. Kelley Ford was a household name around Springfield in the 1930s, when this photograph was taken. The business was located on the corner of North Fountain Avenue and North Street.

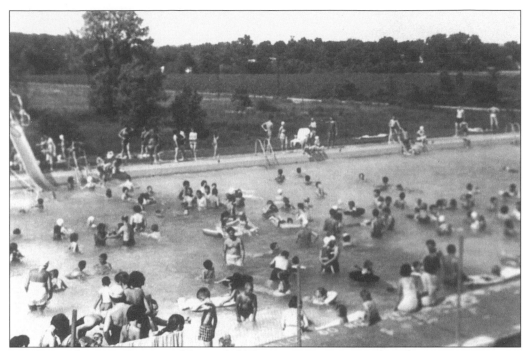

Families in the 1940s frequented Springfield Springs, a private swimming business, every year. Its tree-lined location on Route 40 was an ideal spot for leisurely summer afternoons.

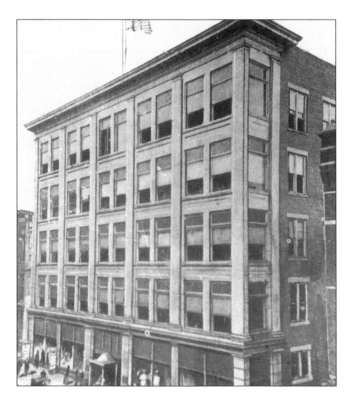

Ed Wren constructed this building, shown in a 1910 advertisement, as a family-owned department store in 1877. It later became a Sears store, and more recently, a parking lot.

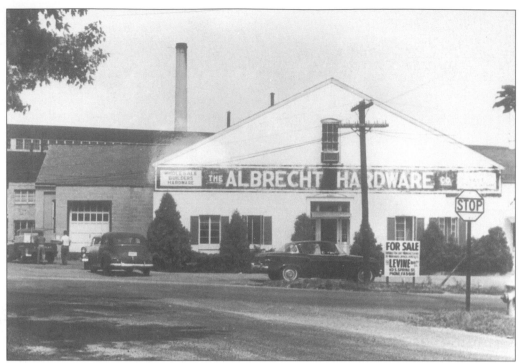

Pictured here is the Albrecht Hardware store, located at the corner of Wheel Street and old Columbus Road, in the late 1940s or early 1950s.

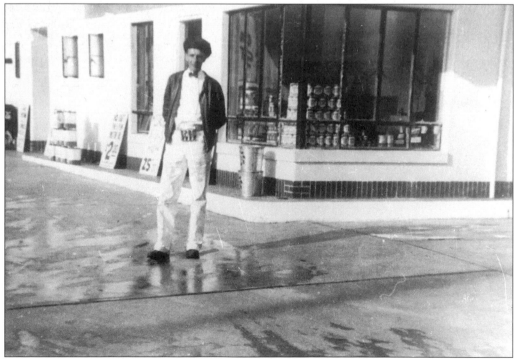

An employee poses in front of the Bonded Oil Company, which originated in the 1930s at the corner of West High and Yellow Springs Street. The building remains standing today.

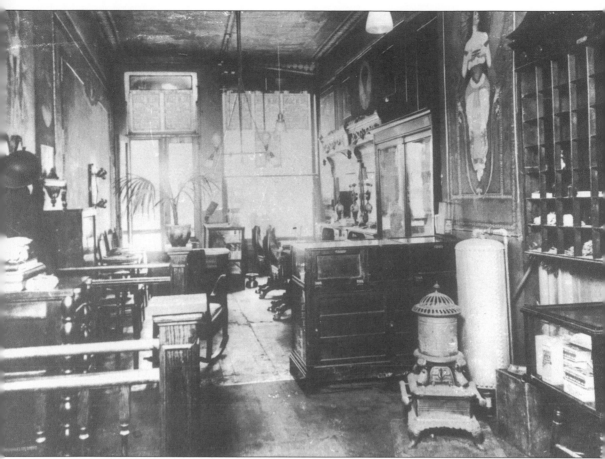

The water heater and shaver mugs to the right of this photograph mark the building as an early 20th century barber shop. This one was located at 539 West Main Street, and owned by Mr. John Etzkorn.

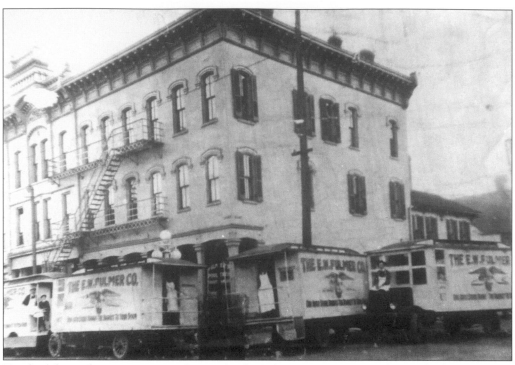

Trucks delivered groceries to area homes for the Fulmer's grocery store chain, which was housed in the Haucke Building, pictured here in the 1920s.

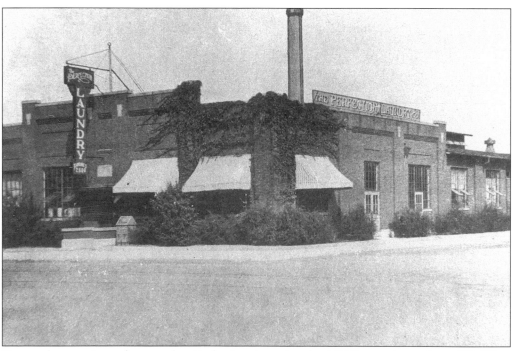

Now a bus station, the popular Perfection Laundry (*c.* 1920) was located at 600 West Main Street.

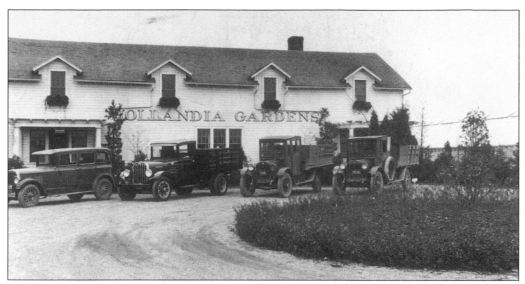

An early 1920s view of Hollandia Gardens in South Vienna, a wholesale and retail establishment, shows their fleet of trucks.

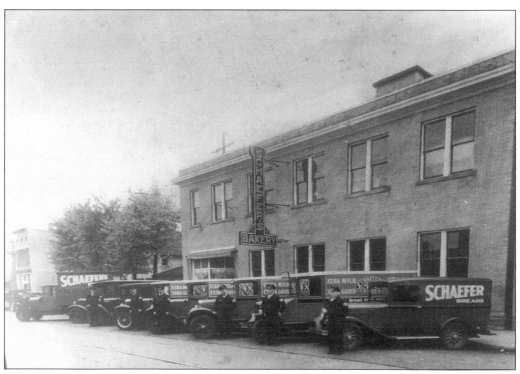

Schaefer's Bakery was a well-known bakery, with a full fleet of trucks prepared for city-wide delivery in the 1920s.

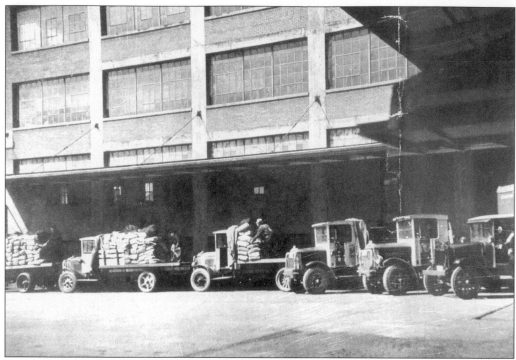

A 1920s photograph features the Collier Building, where the Kelly Trucks would go as fast as fifteen miles per hour to unload their magazines at the freight depots.

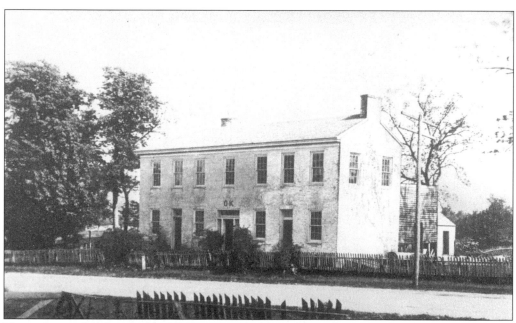

Not to be confused with the Oll Korrect in Urbana, Ohio, this 1890s hotel, located in Sugar Grove west of Springfield on Route 40, greeted guests with the letters 'OK' above the building entrance.

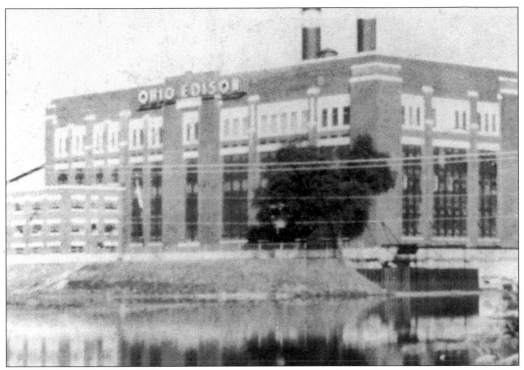

Though the Ohio Edison Company's Mad River location no longer functions as a power plant, as it did here in the 1930s, the building still stands along Route 40 West.

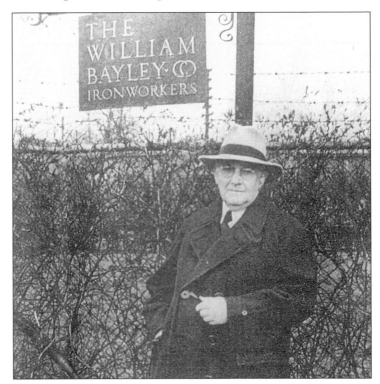

Looking quite proper beside the family business marker is one of the Bayley sons in the 1920s.

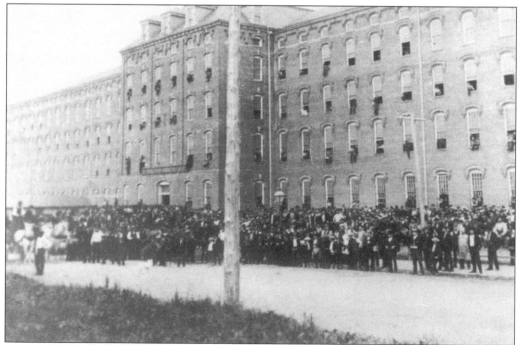

Thomas Manufacturing Co.
Springfield, Ohio.

LAWN MOWERS *and* **IRON PUMPS**

"LARGEST RAKE AND TEDDER MANUFACTURERS"

This advertisement from around 1900 showcases the goods for which the Thomas Manufacturing Company was best known: lawn mowers, iron pumps, and farm equipment. One can only wish for bygone days in imagining the turn-of-the-century prices listed in Thomas's free catalogue.

The building above is the famous East Street Works in the 1890s. It was the largest factory complex in the United States, second worldwide only to Krupps in Germany. The East Street Works operated several different plants under one roof. On February 10, 1902, fire destroyed the structure, which was never rebuilt.

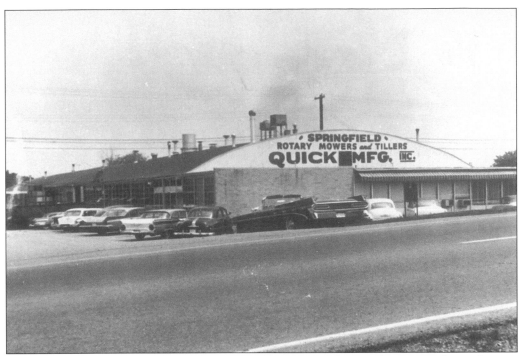

The site of the old Ontario Store along Route 40 East, Quick Manufacturing—shown here in the early 1950s—made rotary mowers and tillers. The busy parking lot seems a testament to its success.

This photograph shows the Ross-Willoughby Company on North Center Street, still in business today in a different location, just after the turn of the century. The W-W Electric Company got its start in this building in 1931.

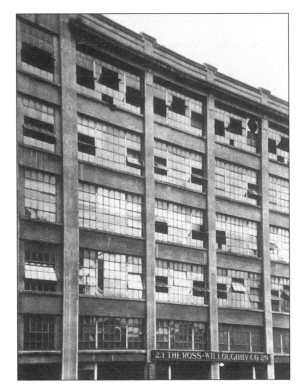

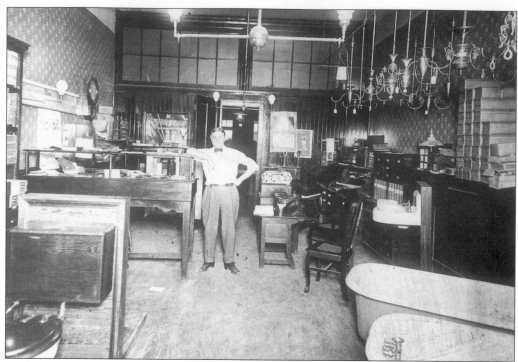

Wilbur Baxter, of the Baxter Nafz Plumbing Company at 17 North Fountain Avenue, stands among his offerings in the early 1910s. Note the elegant furnishings and light fixtures that contrast the practicality of today's plumbing business.

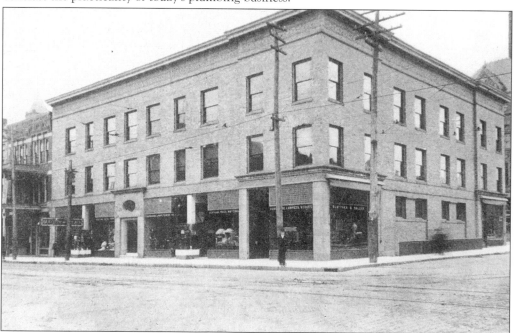

This building was located on the southeast corner of West High and South Center Street in the early 1900s, when this photograph was taken. Visible in the background is the Old City Hall, future setting of the Springfield Heritage Center.

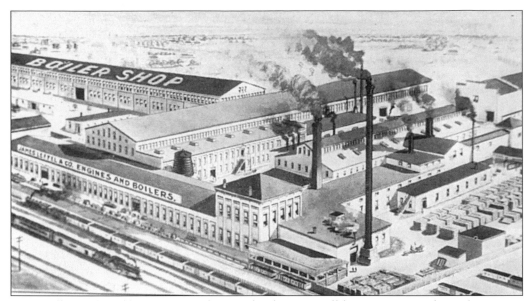

Eventually purchased by a company from Finland, James Leffel & Company—shown here in an early 20th century aerial shot—employed many men to manufacture engines and boilers at this East Street location.

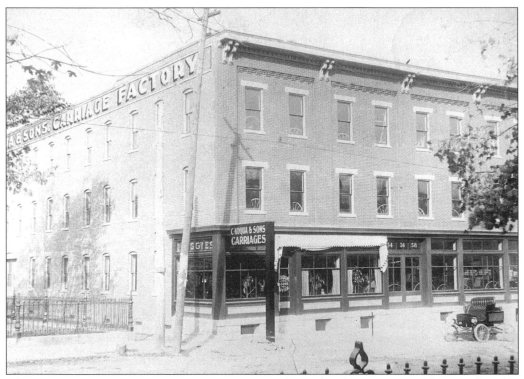

The Kuqua & Sons Carriage Factory once rejected an offer from Henry Ford to produce his automobiles for a payment of five dollars per day. The building appears here in a photograph from the 1920s, well in advance of Mr. Ford's proposal.

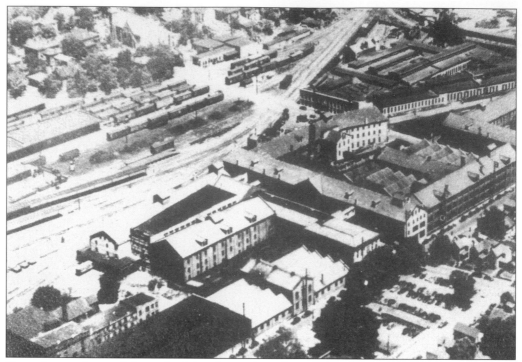

Once the employer of the author's brother-in-law, Springfield's Oliver Corporation was known in the 1940s as the nation's largest manufacturer of farm equipment.

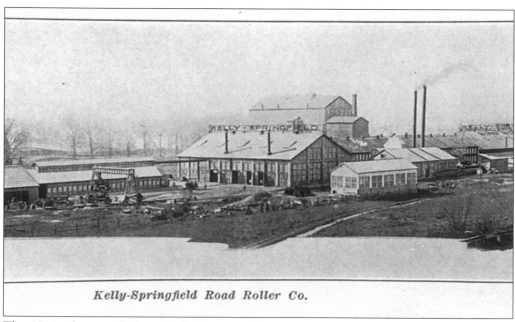

Kelly-Springfield Road Roller Co.

This 1910s photograph shows Kelly Springs Roller Company, later to become Buffalo, and later still Bomag.

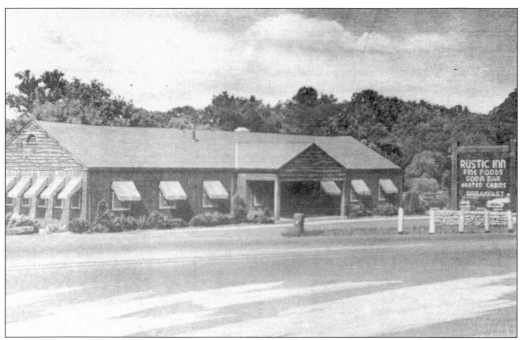

The Rustic Inn & Motor Court was known for outstanding food and sodas. Pictured here in the 1940s, it was located on Route 40 west of the Madonna of the Trail.

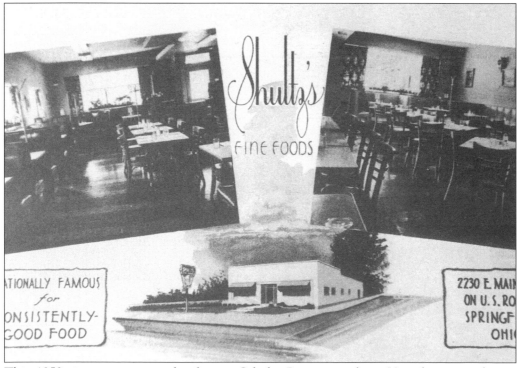

This 1950s image promotes the famous Schultz Restaurant, later Ungerleiters, and now Linardo's Restaurant.

Menus

Arcade Hotel
Springfield
Ohio

Those out for a night on the town in 1927 might find themselves at Springfield's Arcade Hotel restaurant, where an elegant meal consisted of English Beef Anglaise or Boiled Smoked Ox Tongue for 75¢, or Broiled Pork Chops with French Fries for 60¢.

Despite its boast to bring back the atmosphere of "Ye Olden Days," the Wagon Wheel Restaurant was popular with Springfield's younger crowds of the 1940s. The menu of this State Theater district eatery featured sandwiches, phosphates, and a full variety of "egg drinks."

THE WAGON WHEEL

The purpose of the "Wagon Wheel" is to give you the Atmosphere of "Ye Olden Days" in the meantime serve its patrons with the most Delicous Foods possible. To carry its products in the new method of refrigeration, obtain foods from the most well known producers and keep same in sanitary manner.

Our courtesy originates from the school of our Pioneer days.

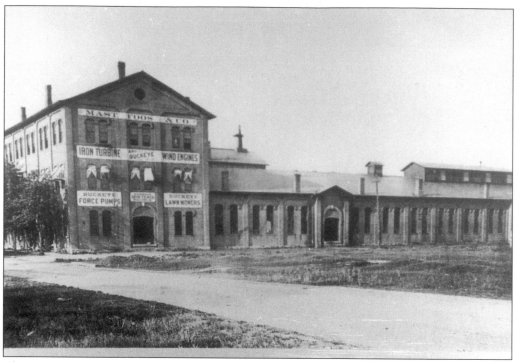

The Mast, Foos plant produced many things, but was most widely known for lawn mowers. Its original location was Isabella Street, shown here in the 1920s, but the company eventually moved to Innisfallen Avenue.

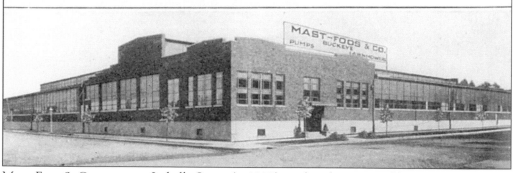

MAST, FOOS & CO.
SPRINGFIELD, OHIO, U. S. A.

Mast, Foos & Company on Isabella Street (*c.* 1910) produced pumps and lawn mowers.

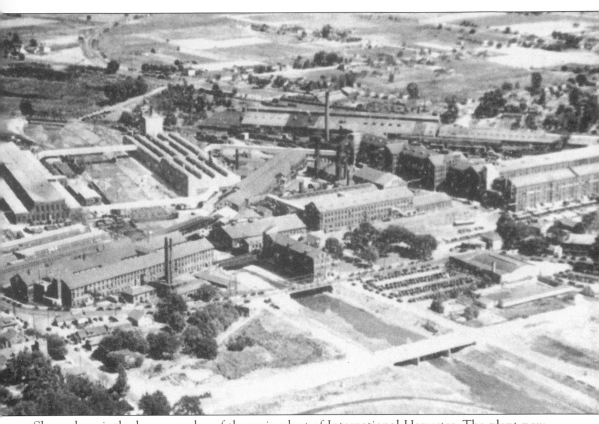

Shown here is the busy complex of the main plant of International Harvester. The plant now operates with only one bridge. Springfield is known as an industrial center precisely because of manufacturing efforts like those of International Harvester.

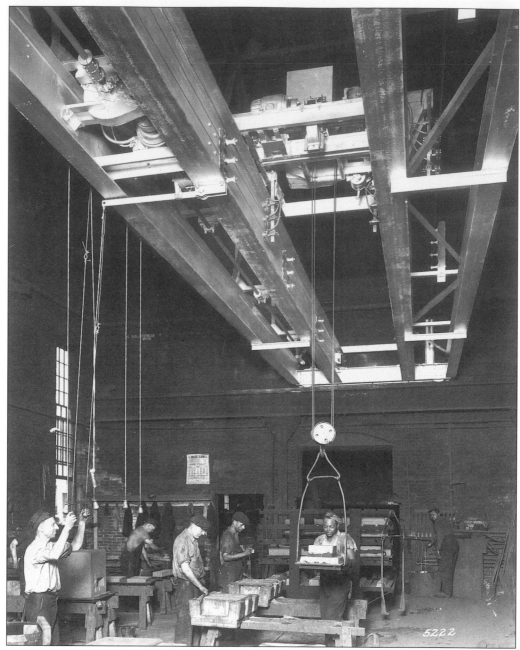

This 1960s photograph of the Springfield Machine Tool Company provides a window into the intricate work of manufacturing lathes. It took several men to operate the complex pulley system pictured here, and several more to keep operations smooth on the floor. Fortunately, the slim window to the left provided natural light and ventilation, as well as an occasional glimpse of the world outside.

Six

PARKS, CHURCHES, AND FUNERAL HOMES

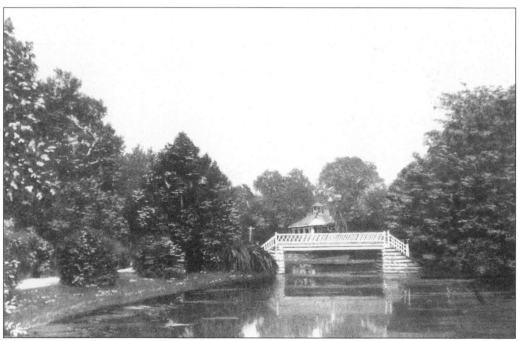

A 1920s image showcases the foot bridge and lake in the placid setting of Snyder Park. Visible just behind the bridge is a gathering place for Springfield residents seeking shelter from the outdoors.

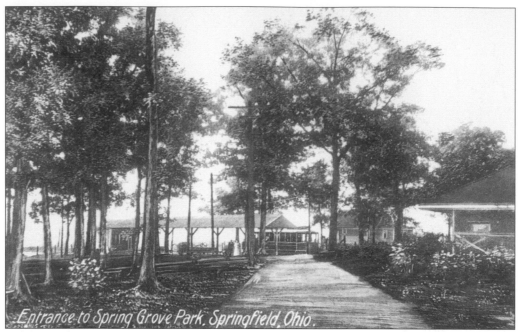

Entrance to Spring Grove Park, Springfield, Ohio.

The tree-lined entrance to Spring Grove Park at dusk is illustrated by this 1910s vintage postcard.

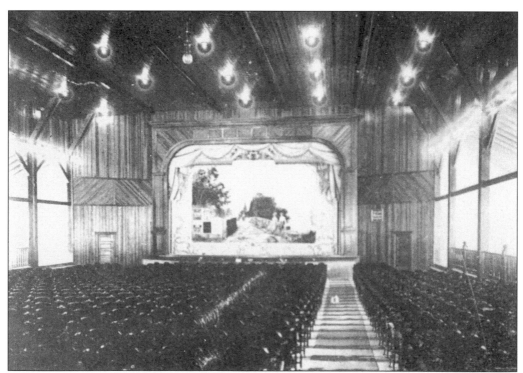

Here is a 1910s glimpse inside one of Spring Grove Park's many buildings, a theatre that staged programs during the popular Union Picnics.

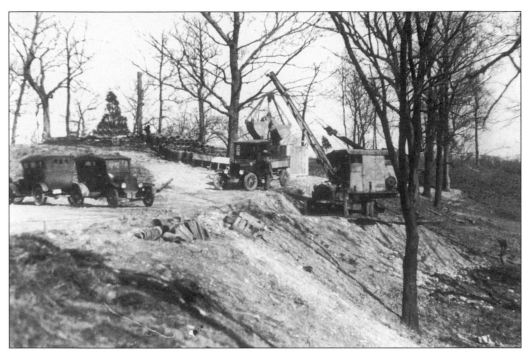

Equipment paves the way in 1920s for what would become George Rogers Clark Park, a lovely Springfield natural landscape.

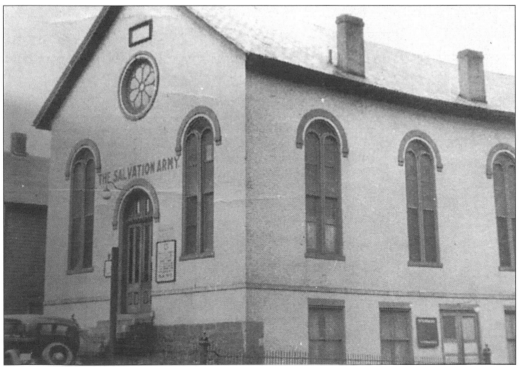

This photograph from the 1930s shows the Salvation Army in the original St. John's Lutheran Church on Fisher Street.

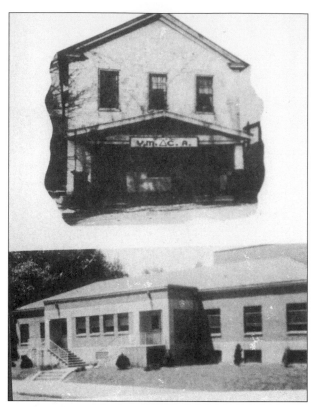

Shown here are two incarnations of Springfield's YMCA. The top, once located in the 400 block of South Center Street, was restricted to the city's African-American population. The bottom, a more modern institution at 519 South Center Street, currently operates as the Urban Center.

This is a 1970s photograph of the old YMCA building on North Limestone Street. The organization is now combined with women's facilities on South Limestone Street.

Second Missionary Baptist Church continues to be busy place over fifty years after this 1945 photograph was taken.

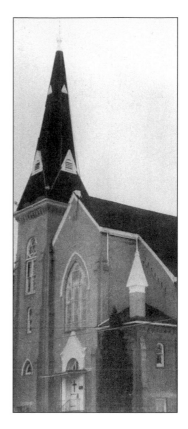

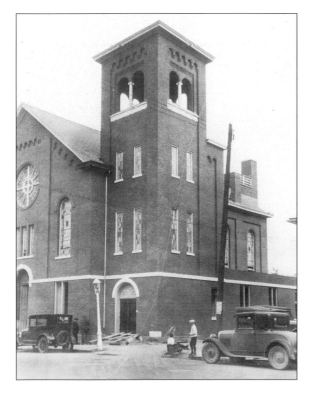

The North Street African Methodist Episcopal Church, *c.* 1920, was located on North Street behind the present post office and across from the Springfield News-Sun building.

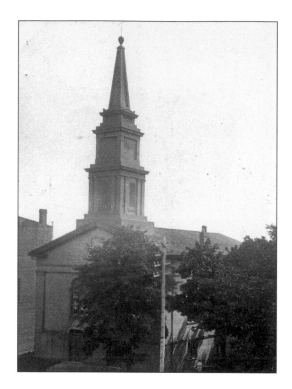

Before moving to its eventual Miller Street and South Fountain location, the First Baptist Church, shown here in the late 20th Century, claimed the corner of High and Limestone Streets.

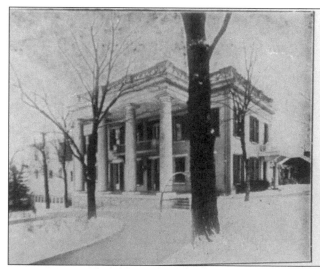

Gustavus Foos of the Foos Manufacturing Company, maker of gasoline engines, originally lived in the building that came to be known as the C. F. Jackson Funeral Home, located at 560 East High Street. The funeral business, pictured here in a 1930s advertisement, maintained close ties with Springfield's New City Hospital.

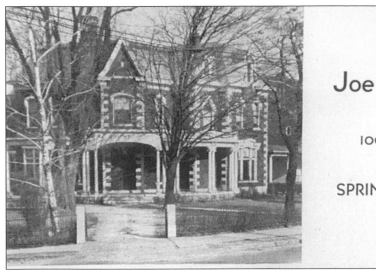

Joe C. O'Brien

1002 E. High St.

SPRINGFIELD, OHIO

This residence at 1002 East High Street was built for the Blee family, who ran the local brewery. It came to be known as the Jones-Kenny-Zechman Funeral Home some years later, but belonged to Joe C. O'Brien when this 1930s photograph was taken.

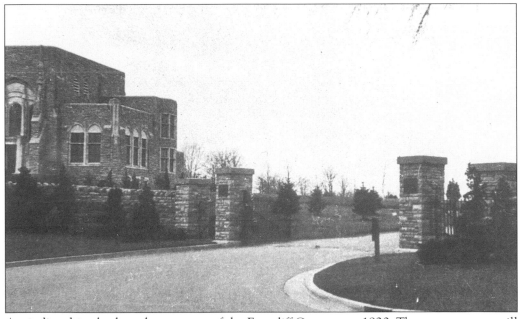

A winding drive leads to the entrance of the Ferncliff Cemetery c. 1920. The cemetery can still be visited in its natural wooded setting at 501 West McCreight Avenue.

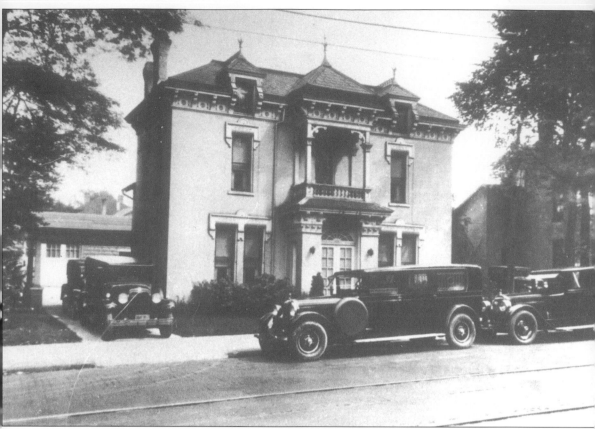

Littleton Funeral Home, located on South Limestone Street, bought this residence in approximately 1920. It remains standing on the site pictured here, but now serves as an apartment building.

Seven

FROM TRAIN TO BRIDGE TO AIR

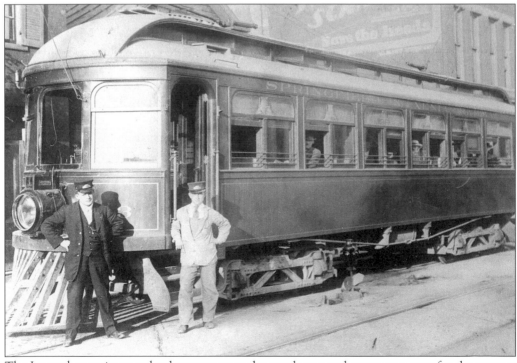

The Interurban waits to unload passengers as the conductor and motorman pose for the camera in this 1920s photograph. This particular car was part of the Springfield & Xenia Railway line.

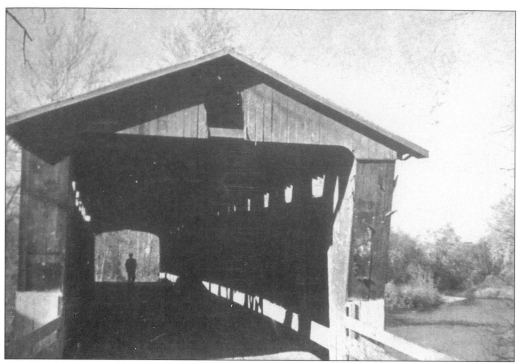

A solitary figure stands before the covered bridge that connected Snyderville to George Rogers Clark Park in the early 1900s. The bridge eventually fell into disrepair and was never replaced.

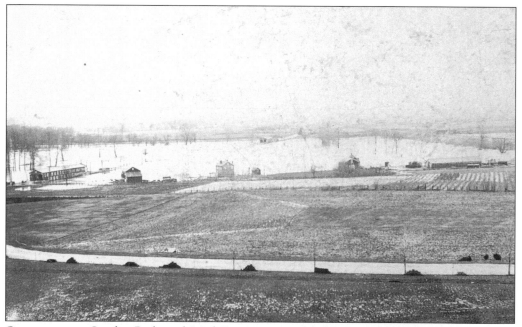

One gazing at Snyder Park and Mad River's covered bridge in the 1890s could not have conceived the changes on the horizon: a flood would devastate Snyder Park, and both the Ohio Edison Mad River plant and the Masonic Home would eventually break ground on this land.

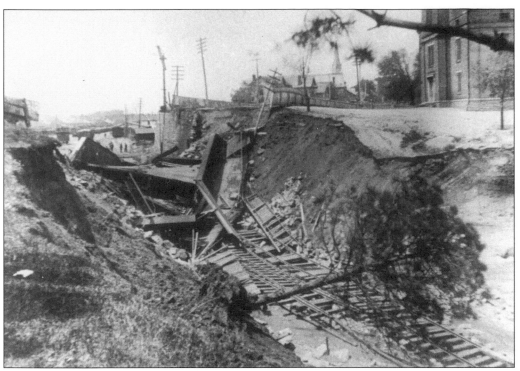

This photograph documents the flood damage associated with an overflow of Mill Run on May 12, 1886. A view from the East High Street Bridge makes visible the old Eastern School, eventually replaced by McKinley School.

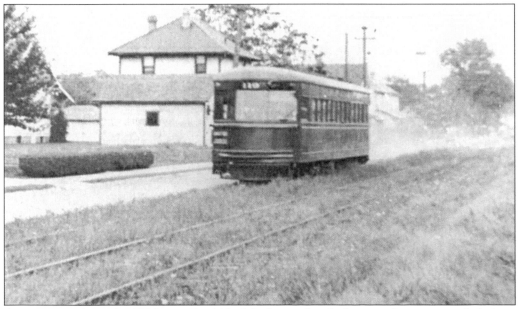

A common sight in the 1920s was Car 119 of the Interurban kicking up dust as it traveled along North Street. The train played a large part in Springfield's history, delivering passengers to and from the city for purposes of trade and leisure.

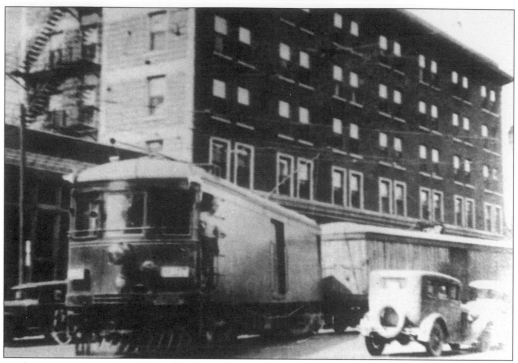

In this image from the 1920s, the Interurban pulls into the station to unload freight near the Heaume Hotel on Columbia Street. The station now doubles as Springfield's Safety Building.

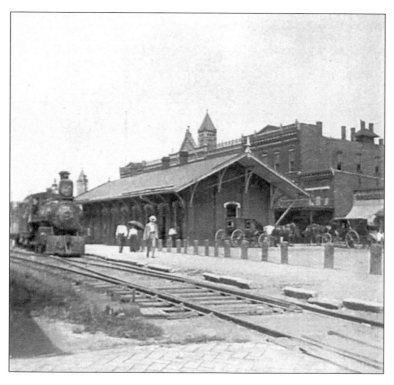

This photograph from the early 1910s features a depot in downtown Springfield. Visible in the background are the Marketplace steeples, which are now being replaced after earlier removal.

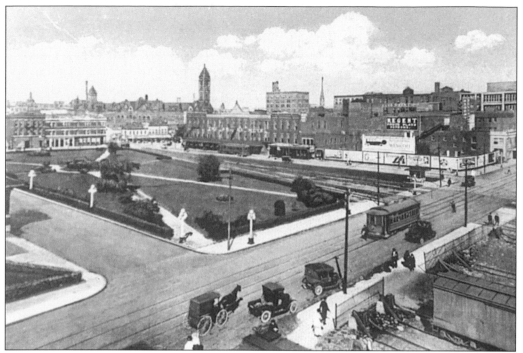

Visible in this 1920s image are the Pennsylvania depot, Regent Theater (far right), and Big Four Park, now the parking lot for the Clark State Performing Arts Center. A magnifying glass would be required to discern the advertisement for Westcott Auto on the top of the billboards.

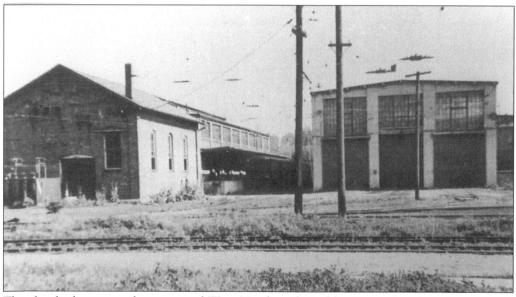

This freight house on the corner of West North and Zischler Street functioned as a repair station for interurbans. The building, pictured here in the 1920s and still standing today, currently operates as a plant.

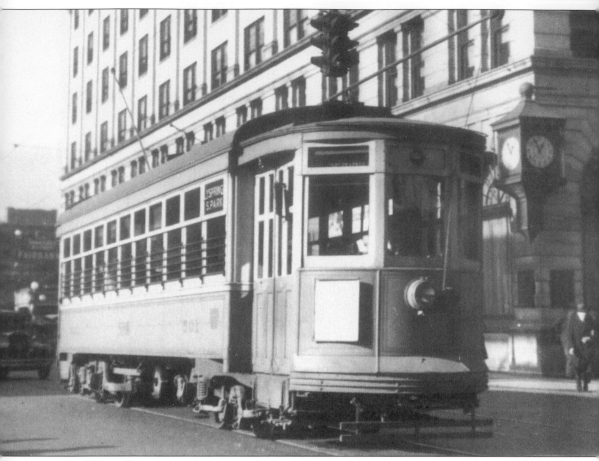

A 1920s trolley car speeds past the front of the First National Bank, located in the Fairbanks Building. This was a common mode of transport at the time for Springfield residents and visiting shoppers.

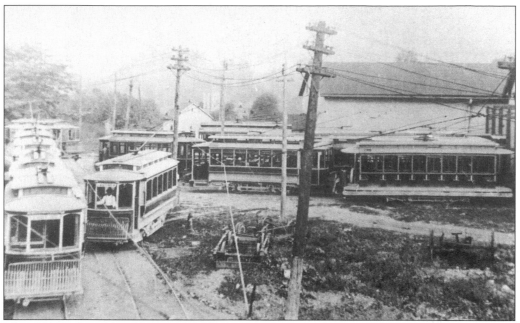

The old Warder Street barns were a haven for street cars in the early 1900s. Here, operators ready the cars for transporting passengers.

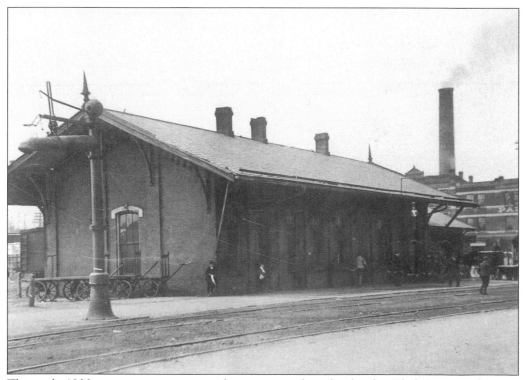

This early 1900s train station rests on the current parking lot for the Clark State Performing Arts Center. Visible on the right is the old Palace Hotel, where the Clark County Library stands today.

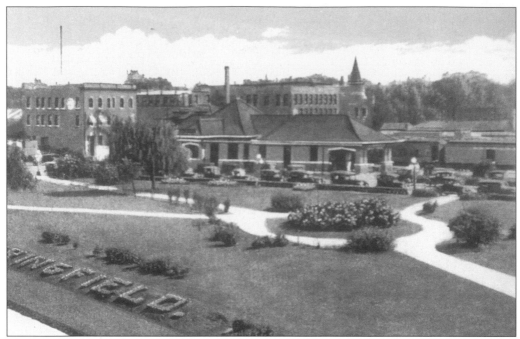

The Clark State Performing Arts Center now resides where the old Pennsylvania Railroad Station used to operate. The building, shown here c. 1930, had an interim phase as the Sears Farm Store.

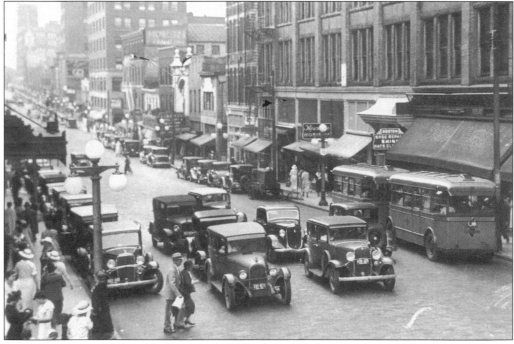

Bus service began in Springfield around 1934, when this photograph was taken. The result was increased foot traffic to many of downtown Springfield's most popular gathering places, such as High Street's Liberty Theatre and Wren's department store.

W. T. Hough & Sons general store also sold gasoline. Here, a 1920s automobile owner fills the tank, located at that time under the car's front seat. It remains unclear whether the woman pictured was actually driving the car, or had moved for the duration of the fill-up.

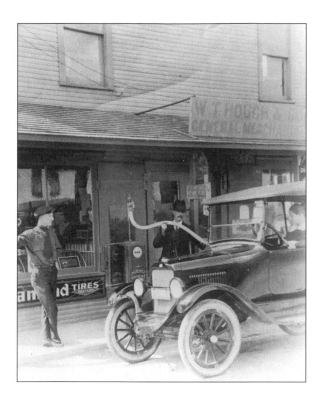

This International Harvesters truck was one of four belonging to the Springfield Baking Company in the 1920s. The vehicles' reliable performance prompted the company to offer public testimonials as advertising.

The Wagner Moving Company used this International Harvesters truck, *c.* 1930, as part of their standard fleet.

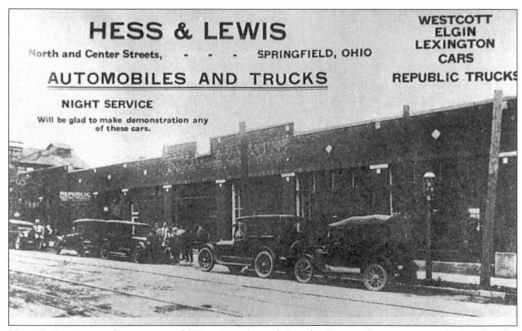

Hess & Lewis, at the corner of West North and South Center Street, was a dealer for the Westcott automobile, manufactured exclusively in Springfield. This 1920s backdrop is the old Ripley Building, currently occupied by Business Equipment.

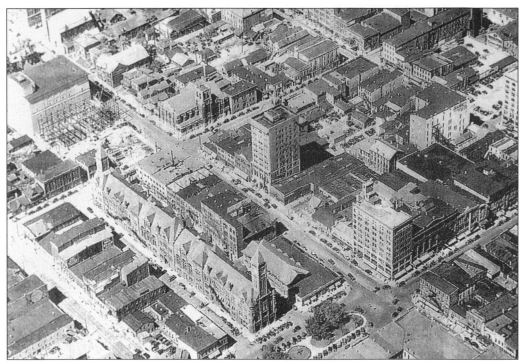

This early 20th century aerial view of Springfield zeroes in on the Marketplace, where the Clark County Historical Society takes up residence in 2000.

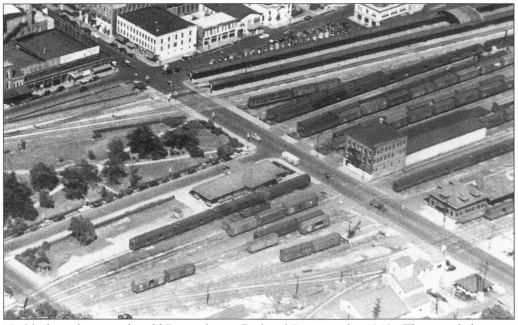

Visible from the air is the old Pennsylvania Railroad Depot in the 1940s. The rounded area at the bottom center of the photograph became the eventual location of the Clark State Performing Arts Center.

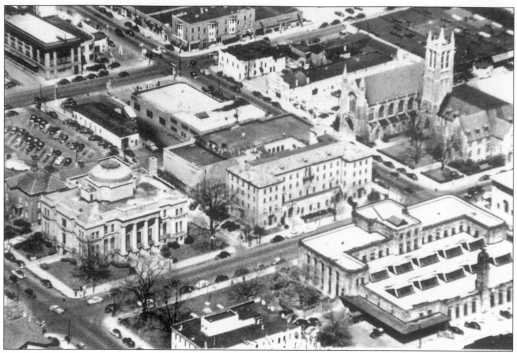

A 1940s birds-eye view reveals the old YMCA across from the post office, the H.G. Root filling station (which also sold appliances), and the sheriff's residence behind the courthouse.

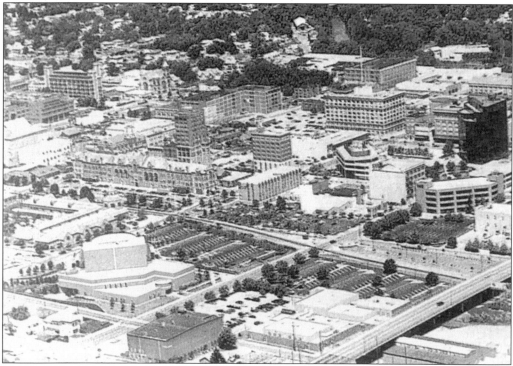

This 1980s photograph offers a contemporary glimpse of Springfield, with the Clark State Performing Arts Center to the left and the Springfield Inn at the center.

Eight
A GLIMPSE OF
CLARK COUNTY

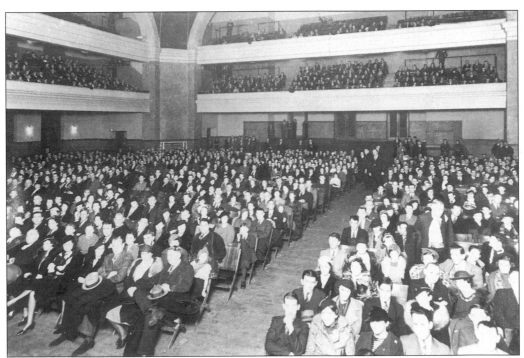

Memorial Hall, as it would have been seen in the 1930s, was a hub of Springfield's cultural activity. The individual who bought Memorial Hall now lives in the old Clark County Children's Home on Lower Valley Pike.

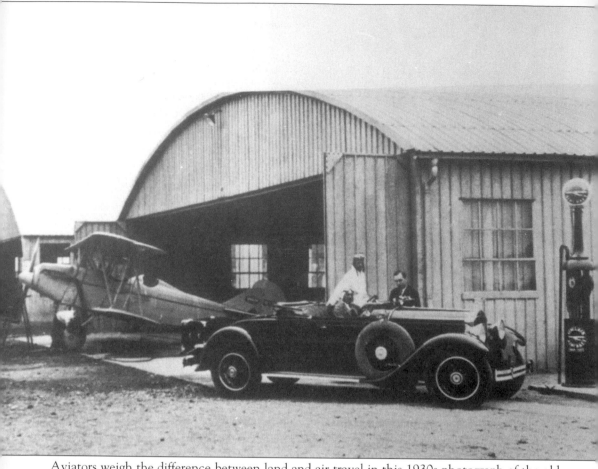

Aviators weigh the difference between land and air travel in this 1930s photograph of the old Clark County airfield, located on what was then Route 70. Notice the vintage gas pump that has become a favored artifact of antique stores and collectors.

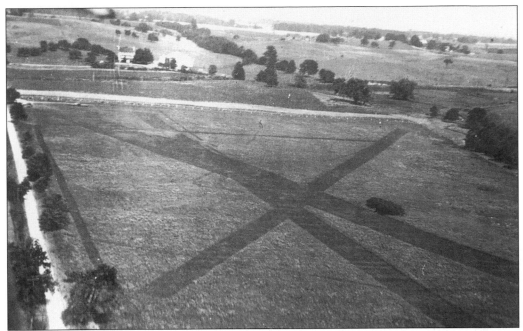

The Davidson Aviation Field is pictured here in the 1910s on Eagle City Road, where Springfield's City Water Works is located today.

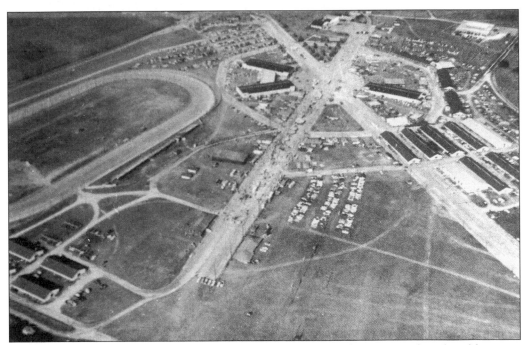

Now home to the Clark County fairgrounds, this patch of land once served as the old county airport. With its apparent runways and airplane hangars, even this 1930s photograph of a county fair in progress recalls the area's roots in aviation.

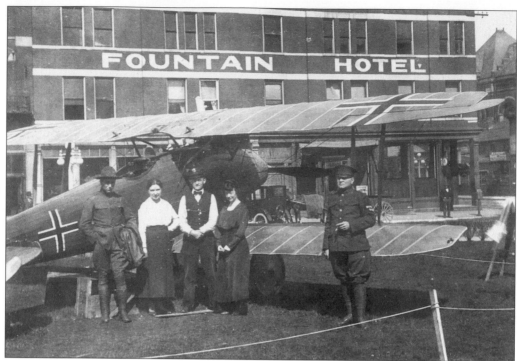

Probably used as a World War I public relations effort, this captured German airplane is displayed in the early 1920s in front of the Fountain Hotel, where the Kuss Center stands today.

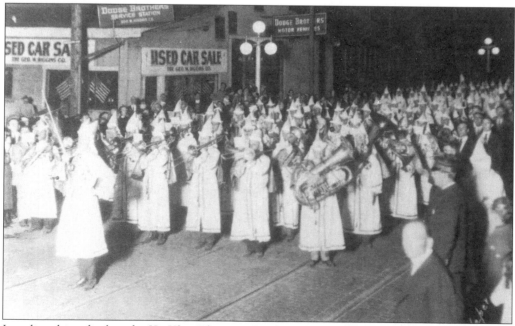

In a disturbing display, the Ku Klux Klan parades through Springfield in 1923.

The National Old Trails Road, known as Route 40 near Springfield, stretched 3140 miles in length at the time this 1930s photograph was taken.

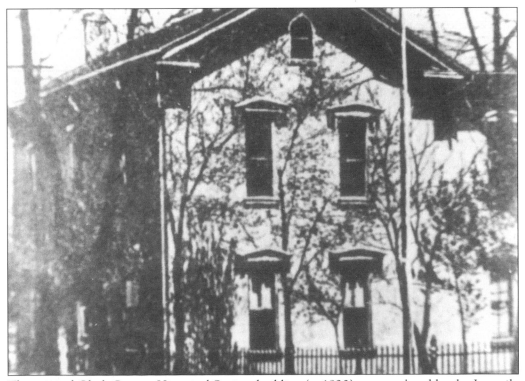

The original Clark County Historical Society building (c. 1920), now replaced by the Juvenile Center, resided at the corner of East Columbia and North Limestone Street.

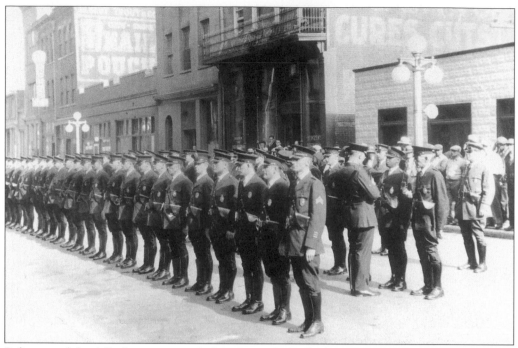

Police stand dutifully for inspection before a crowd of onlookers on West Washington Street in the 1920s.

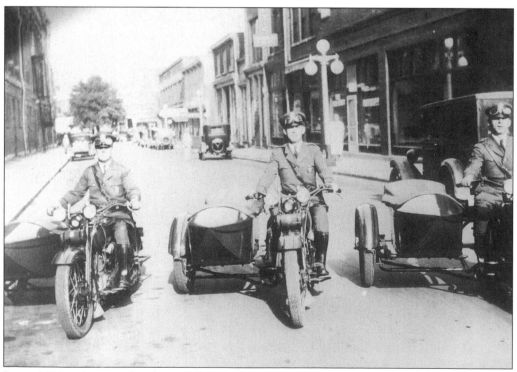

In a 1920s photograph, three policemen pose on motorcycles furnished by the Police Department, then located on the west side of Marketplace on South Market Street.

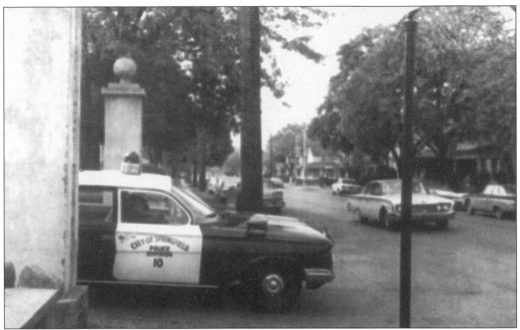

This 1950s photograph shows police waiting for speeders at the corner of Champion and Columbus Avenue.

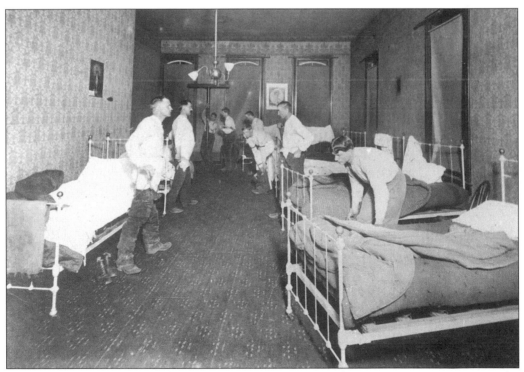

In this 1910s glimpse of the old Fire Department, men rise to begin automatic preparations for fighting a local fire. The quickest already makes his way down the pole, visible in the rear left of the photograph.

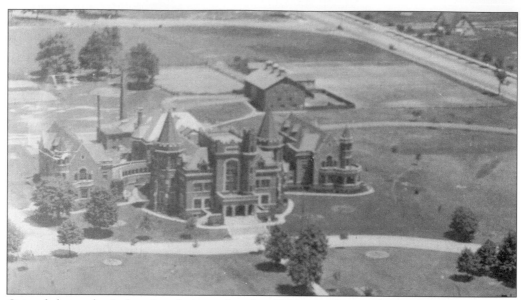

One of the author's favorite photographs, this 1920s aerial view shows the old Knights of Pythias Home, now replaced by St. John's Center (owned by Mercy Medical Center). Visible on the right is North Fountain Avenue.

This image was culled from a late nineteenth century Clark County Historical Society pamphlet detailing Springfield's most notable landmarks. Here, we see an 1878 brick schoolhouse located east of New Carlisle on the New Carlisle Pike.

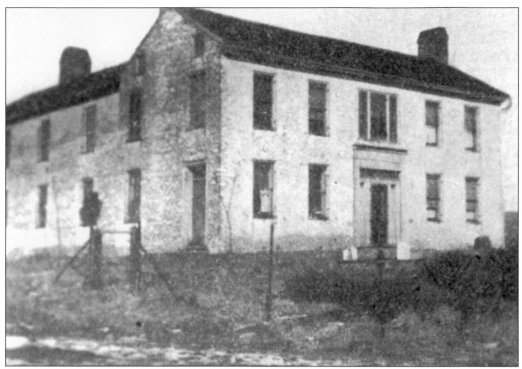

Now an antique store, the Buena Vista Tavern building—pictured here in the 1890s—remains a Springfield landmark.

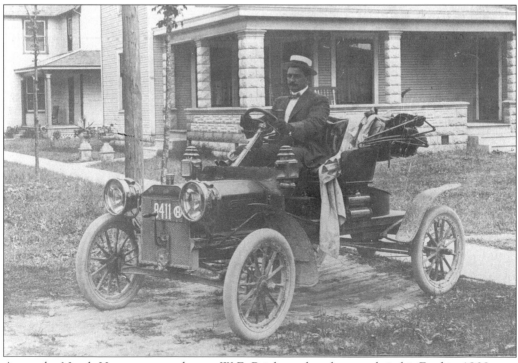

A popular North Hampton area doctor, W.E. Bright makes the rounds in his Ford in 1908.

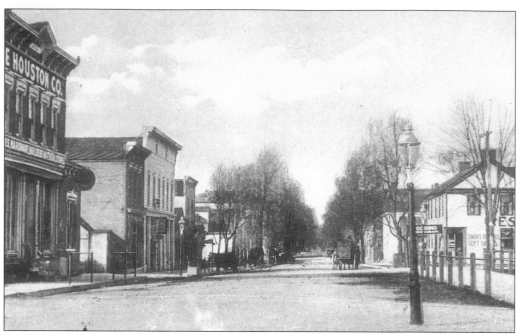

South Charleston, an area approximately 20 miles southeast of Springfield, was known for the quaint downtown area delicately illustrated by this 1890s postcard.

Also a modest Clark County town, Pitchin—originally called Concord—is approximately five miles from the Springfield city limits, yet too small to appear on many state maps. This 1910s photograph of what may be a tavern gives a feeling of the area's wide open spaces.

Nine
SPRINGFIELD EVOLVES

Run by a Greek family, The American was the popular corner restaurant featured in this 1930s photograph. It was known for fast, tasty sandwiches and desserts, but also sold tobacco products for those who might care to linger.

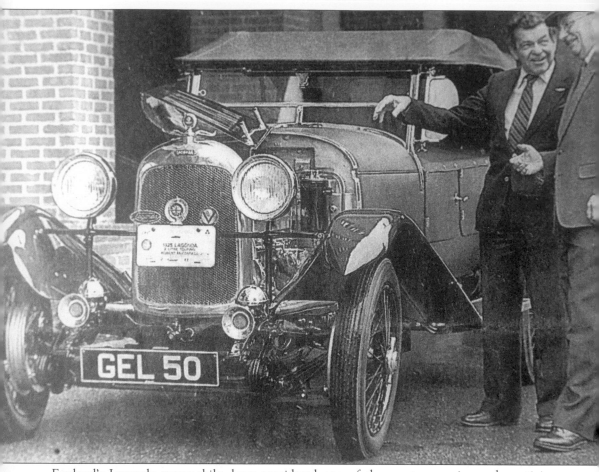

England's Lagonda automobile, long considered one of the most expensive and prestigious sports cars in the world, was invented and produced by Springfield native Wilbur Gunn. The Lagonda also inspired the name of a local creek, and was a featured attraction of the October 1999 Champion City Heritage Celebration.

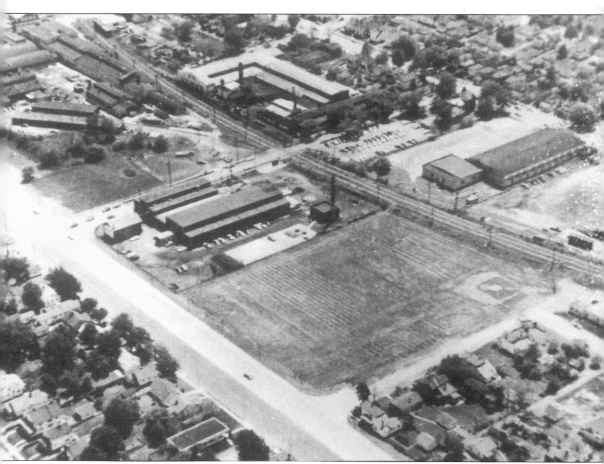

This 1950s aerial view shows a baseball diamond, once owned by the Steel Products Engineering Company. A Rodeway Inn motel now stands in its place.

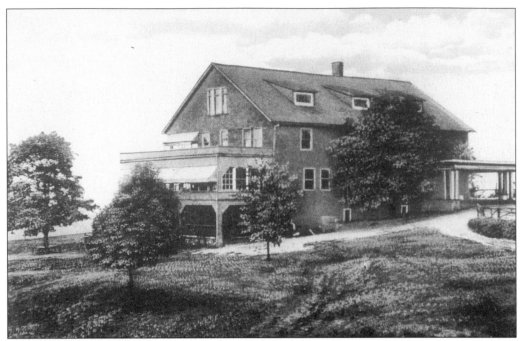

Here is the Springfield Country Club as it looked in the 1910s, when residents would gather for a light meal or an afternoon of leisure.

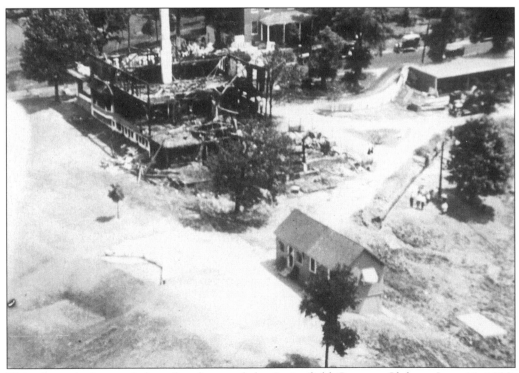

This photograph reveals how fire destroyed the Springfield Country Club on June 14, 1922. Many were saddened to hear of the loss.

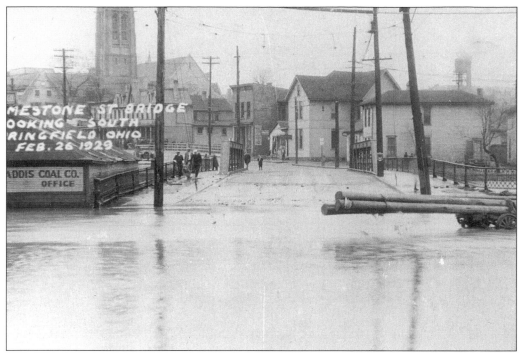

This is a photograph of the devastating flood of 1929. The Riverbend Building now stands in this location.

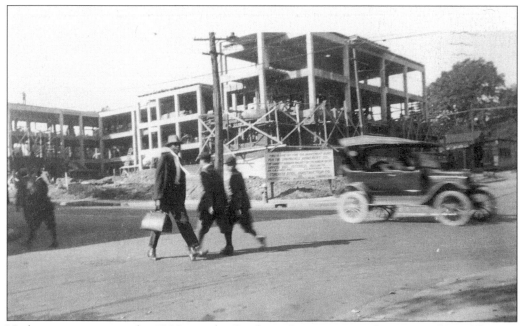

Under construction in the 1910s are the Southern Apartments at the corner of East Pleasant and South Limestone Street.

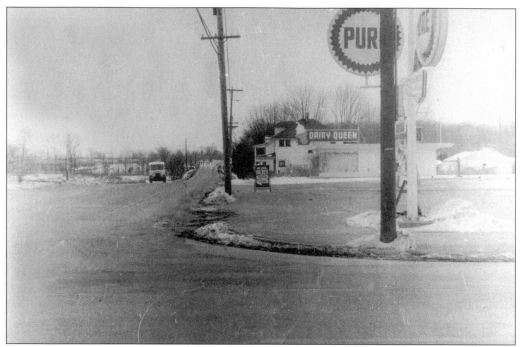

The 1960s Dairy Queen pictured on the corner of Home Road and North Limestone Street remains standing at that location today, but is now surrounded by a BP gas station and Big Bear grocery store.

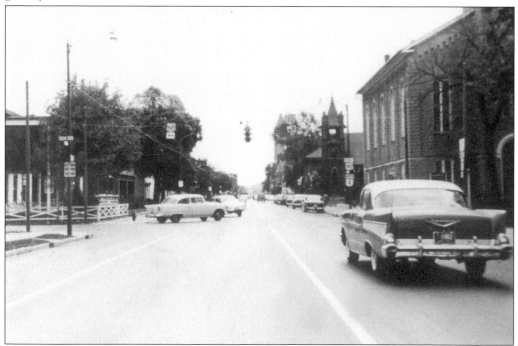

The Chevrolet in the foreground approaches the intersection of West Columbia and North Plum Street, where an Executive Inn stands today. During the 1950s, those driving along this stretch would have noticed the Zion Lutheran Church across from Pillars Rest Home.

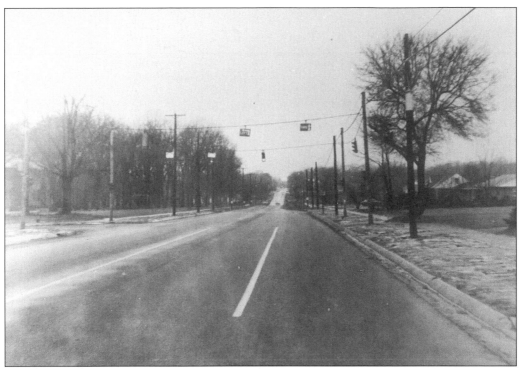

Looking west down Home Road from the front of North High School, one might discern the Clark County Children's Home, visible on the left of this 1960s photograph.

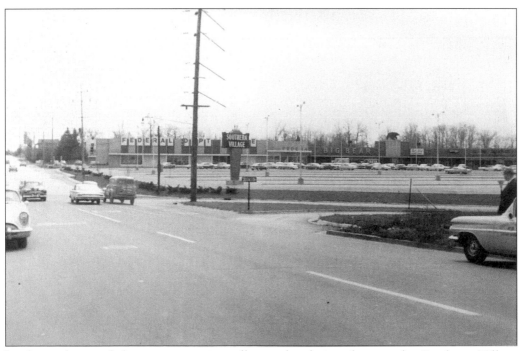

In the tradition of the one-stop strip malls popular during the era, the Southern Village Shopping Center was built on Selma Road in 1955.

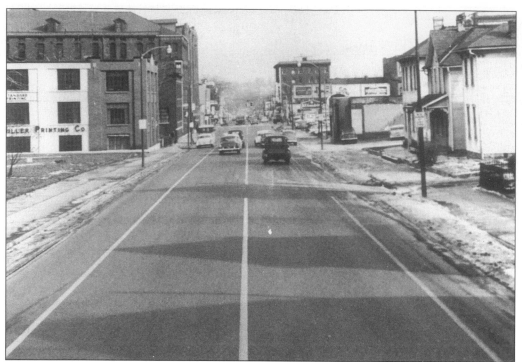

This is how West Columbia Street appeared in the 1960s, when Miller Printing was located downtown. Also in the vicinity was a cemetery known as The Burying Ground.

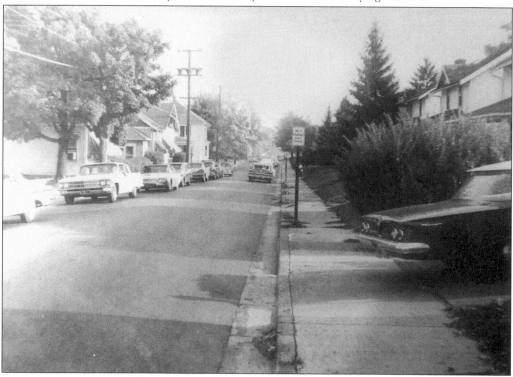

Here is a look down South Burnett Road just off Main Street in the late 1960s.

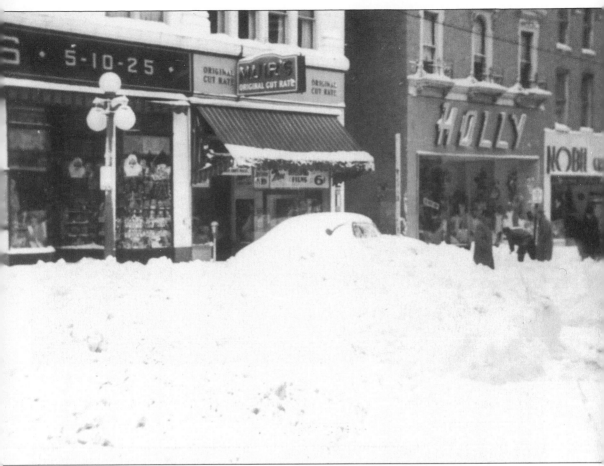

Muir's Drugs and the Holly Store are rendered nearly inaccessible by a November 25, 1950, storm that buried Springfield in several feet of snow, and surely affected the outcome of the Ohio State vs. Michigan football game being played in neighboring Columbus. Along Limestone Street, residents attempt to clear sidewalks and dig out hidden automobiles.

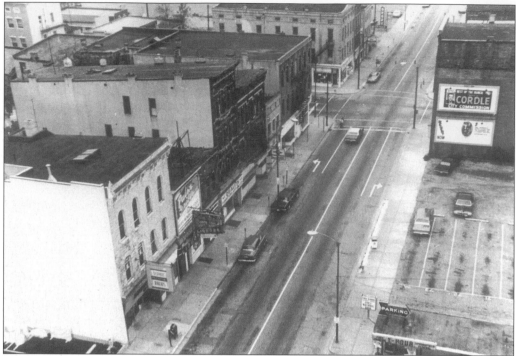

Main Street from the air in the 1960s offers a unique view of Schmidt Drug Store and the Palm Grills Bar. The political billboard (upper right) proved highly successful, as Max Cordle served not only as a Springfield city commissioner, but also as assistant mayor in the early 1970s.

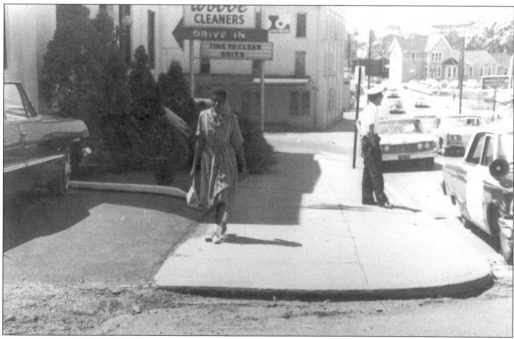

Wobbe Cleaners, now Dolbeers, on North Limestone Street readies itself for the fall suit-cleaning rush during a 1970s summer afternoon.

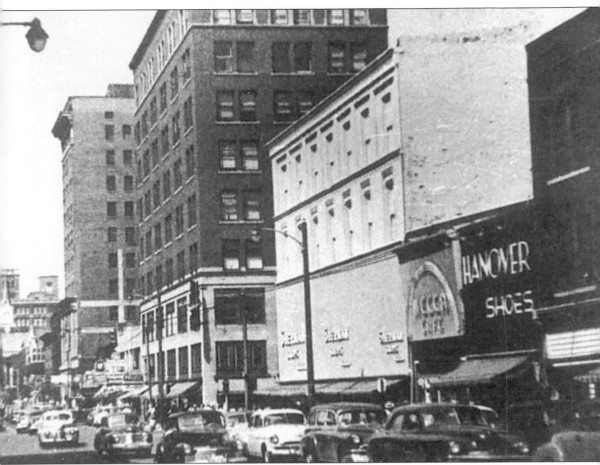

The Hanover Shoes and Mecca Grill these shoppers would have encountered in the 1960s have since been replaced by the Oracle Vision monument.

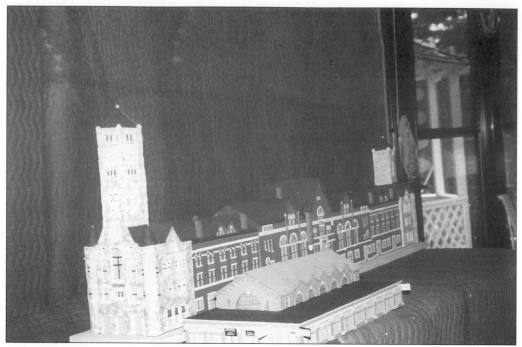

Bill Swonger constructed this replica of the Old City Hall Marketplace, now home to the Clark County Historical Society.

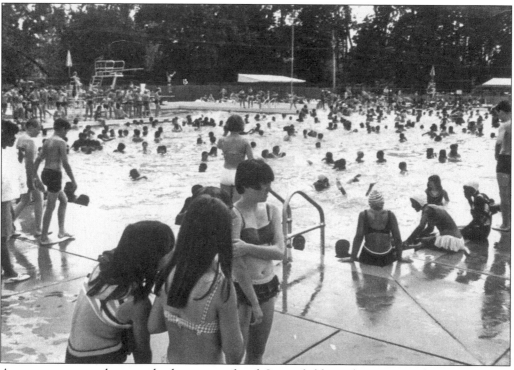

A contemporary photograph shows crowds of Springfield residents engaged in a common summer pastime: visiting the city swimming pool.

126

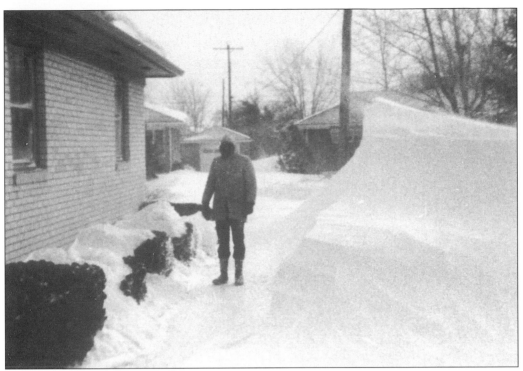

The author's son Donald helps clear away snow after an unexpected storm in January of 1978.

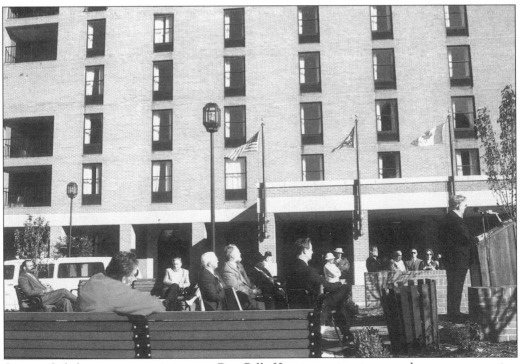

Surrounded by city commissioners, Dr. Bill Kinnison gives a speech commemorating Springfield's new fountain in the Esplanade in 1993.

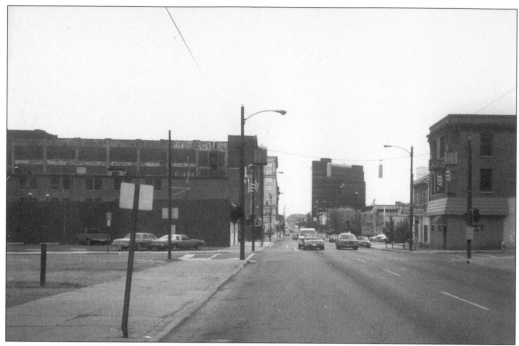

A view looking east down present-day West Main Street features the Credit Life Building, now owned by the Lagos family, in the center.

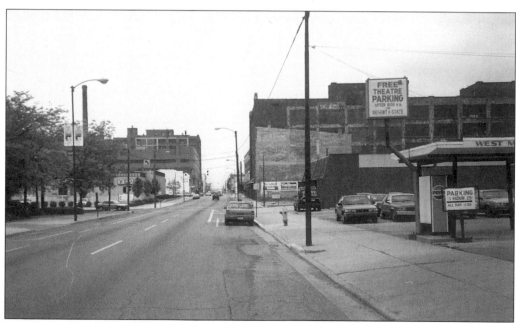

This is the same block of West Main Street from a western vantage point. The Crowell Collier Building appears in the center, while the parking lot for the Central Methodist Church is visible on the left. One can't help but compare this image against Springfield's Main Street of 1909, pictured on page two of this book. The entire landscape has been transformed during the course of Springfield's remarkable evolution.